BALENCIAGA

First published in the United States of America in 1997
by UNIVERSE PUBLISHING
A Division of Rizzoli International Publications
300 Park Avenue South
New York, NY 10010

and THE VENDOME PRESS

ISBN 0-7893-0091-5

Printed and bound in Italy

Library of Congress Catalog Card Number: 97-61200

BALENCIAGA

BY MARIE-ANDRÉE JOUVE

UNIVERSE / VENDOME

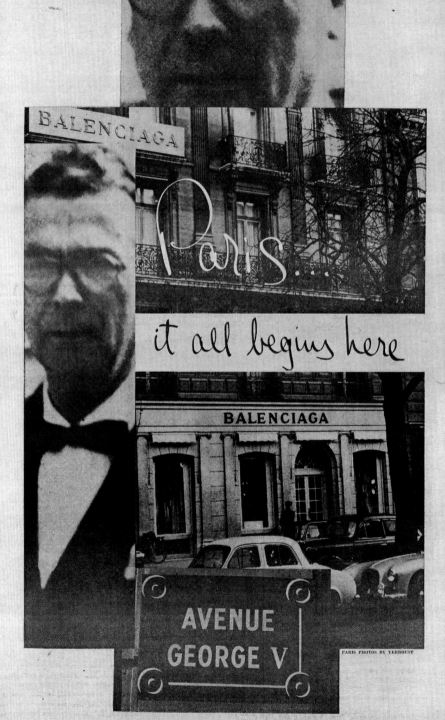

Paris....

it all begins here

BALENCIAGA

AVENUE GEORGE V

PARIS PHOTOS BY VERROUST

A woman has no need to be perfect or even beautiful to wear my dresses, the dress will do all that for her. Cristobal Balenciaga

When Poiret made his exit from the world of couture in the 1930s, he wrote: 'Fashion needs a new master to set women free as I did in my day, someone who will give her what most becomes her and who will pursue his ideal without letting himself be swayed. He will become famous and, amid general adulation, will attract disciples and imitators for years to come.' To whom could these prophetic lines better apply than to Balenciaga?

Following the outbreak of civil war in Spain in 1936, Cristobal Balenciaga was forced to close his three couture houses and leave his native country. He arrived in Paris in 1937 and there, thanks to the generosity of friends from San Sebastián who were fellow refugees, he was able very soon afterwards to open his own couture house on the Avenue George V and to present his first Paris collection in August of that year. There was instant recognition of the talent and style that had ensured his reputation in the previous twenty years. In February 1939, the *Daily Express* ran a story about

the 'young Spaniard' who was revolutionizing fashion, describing how buyers and press literally fought to get into his collection, for all the world as if it were a football match. At the same period, a fashion programme broadcast on Radio 37 judged the collection enchanting, singling out the Infanta dresses and period-style frocks, the impact of fabrics in strong colours, and the ecclesiastical blacks and whites for evening. The *Courrier de la Mode* delivered its verdict: 'Beneath its apparent simplicity, each of these little dresses is a masterpiece of *haute couture*. Examine them closely, and you will discover the subtlety and originality of the cut, and you will conclude there is not a dress to be had at Balenciaga for under 6,000 francs.' Everyone was talking about his famous square coat, in which the sleeve was cut in one piece with the yoke, and his combinations of black and brown.

balenciaga's reputation soared during the war years and the business was a runaway success, and that in spite of the fact that he had to close down for a period of several months, reopening only when the building was threatened with a requisition order. The three Spanish-based businesses continued to trade throughout the war. 'Women from all over the world cross frontiers to buy his creations, which are the object of an amazing trade in contraband,' related one Spanish newspaper.

This was the period of the sumptuous designs inspired by the Spanish Renaissance that Balenciaga created for Alice Cocéa at the Théâtre des Ambassadeurs, and of easy-to-wear indoor clothes for unheated apartments, lined – given the lack of ermine – with white rabbit fur. In 1947, Dior made his triumphal entrance on the international fashion scene, but neither the introduction of his New Look nor the lustre of his name could dim the popularity and fame of Balenciaga, solidly established by then with clients, buyers and press alike. It is enough to recall the enthusiastic articles

written by Carmel Snow in *Harper's Bazaar*, in which she sang the praises of Balenciaga's seeming simplicity, so impossible to imitate, based as it was in rigorous construction and a mastery of execution previously unsurpassed. Christian Dior himself expressed great respect for Balenciaga, whom he liked to call 'the master of us all'. Bettina Ballard, another great chronicler of fashion, tells a story that illustrates the sincerity of his admiration. She remembers being with Dior at a function in San Francisco and the couturier, dazzled by her suit, saying 'Only Balenciaga would be capable of producing such perfection.'

In 1948, devastated by a recent bereavement, the master was ready to call a halt to his work and it was Christian Dior himself who begged him not to close his doors. In the early fifties, Balenciaga launched his first semi-fitted suit, the balloon dress, the peasant shirt and the sailor smock. These were followed by the tunic, the sack dress, tweeds in all their manifestations, and lace stripped of its mystique and used for camisoles and tunics. He left neck and wrists exposed in order to emphasize jewellery and hand gestures. The silhouette created by Balenciaga set a new trend. It expressed a radically different relationship between body and garment, the fluid lines of the latter reposing always on a fundamental classicism from which he never deviated throughout his life, combining elegance and comfort in a perfect harmony of proportions. Through the magic of his cutting, the designer could even permit himself (to the great delight of his clients) to correct any slight imperfections in the human figure beneath . . . the 'Balenciaga miracle', as it was to be dubbed by his great friend Hubert de Givenchy.

For day, a Balenciaga of classic simplicity could pass unnoticed in a crowd. Only an initiate would see the subtle cut and quality of fabric that characterized the Balenciaga style. For evening, however, a Balenciaga gown would stand out by virtue of its boldness and originality and the lustre of its colour and materials, making the woman who wore it as aloof and inaccessible as a work of art.

In 1958, John Fairchild wrote an article in *Women's Wear Daily* describing the extent of his influence: if Balenciaga dictated fashion to the point that other designers copied him, and if the world's richest women were prepared to pay top prices for his clothes, then the upper end of American fashion had to follow suit. Balenciaga, for his part, was curious to see the transatlantic technology about which he had heard so much and he decided to go and see for himself. But on a visit to a ready-to-wear factory in New Jersey he realized that his suits could not be made on machines. It has often been said that Balenciaga could have built a commercial empire as big as Dior's but, mindful of his image, he was content to ignore the blandishments of a mass market and concentrate instead on maintaining his reputation as a couturier of the utmost luxury and elegance. Fiercely independent, he retained control of his perfume business and even preferred not to have his hands tied by joining the Chambre Syndicale de la Haute Couture. Thanks to an extremely wealthy private clientele and very high prices, the House of Balenciaga alone could afford to turn down orders; it had a turnover as big as the other fashion houses even though it employed fewer people.

t he designer's closest colleagues recall a tireless man who could supervise as many as one hundred and twenty fittings in a single day, and yet who would keep an eye on the tiniest details of the collection and who could make a dress or hat with his own hands. 'Hands of an extraordinary agility', says a friend and fellow designer, remembering a fitting in a Madrid atelier: 'The master was like a surgeon surrounded by his team of assistants, operating in total silence, wielding scissors and pins with fascinating assurance, transforming the *toile* into a wonderfully balanced and elegant garment.' Immensely demanding, he would have finished designs unpicked and restitched several times until they

were perfect, and would not hesitate to spend hours of his own time on the cut and setting-in of a sleeve in order to make it sit exactly right, or on ensuring that the seams of a collar were invisible. He personally checked models before they went out to clients, sometimes holding them back, to the great despair of his saleswomen. In the morning, on the atelier tables, staff would often find little notes in Spanish left by Monsieur Balenciaga, these being ideas or changes of mind that had come to him during the night about particular models. His loyal colleague Fernando Martinez recalls that 'His choices and his decisions had an enormous influence on the finances of the fashion market.'

his discerning eye for fabrics, some of which were made specially for him, won Balenciaga the respect of his suppliers. He liked bold materials, heavy cloths, new fabrics, reliefs that caught the light, the transparency of lace set against a variety of backgrounds, and ornate embroideries, often of Spanish inspiration. He matched his own colours using minute samples, sometimes, his secretary tells us, no more than a couple of threads picked up off the workroom floor. In the sixties, he was famous for his immaculate technique and restrained purity of form. All that distinguished the different models were a few subtle touches here and there and the different finishes and weights of materials; he was particularly known for his masterly use of bias-cut fabric in ensembles of linen or crepe. The American press was voluble in its praise of his genius, describing his cutting as a triumph and extolling the elegance of his collections, their overwhelming sense of luxury and beauty. His influence on fashion was then at its height. Although a keen collector of antiques, in reality he lived only for his work. Devoted to the art of couture, he would virtually disappear from view the moment it was time for the collection itself. He might be glimpsed hovering anxiously behind a

curtain watching the proceedings, and his faithful colleagues, who were deeply attached to him, would sometimes come upon him afterwards in one of the ateliers, absolutely drained by worry and lack of sleep, unpicking a model he was no longer happy with. Courrèges, Emanuel Ungaro and Frédéric Castet all learned their craft from him and never ceased to revere him as an exceptional man; they recalled the distinctive atmosphere of almost monastic calm and discipline that prevailed throughout the premises. In the salons, the models were forbidden to smile and they too maintained total silence as they paraded, heads held high, gazing into the distance, waist and hips thrust forward as their master had taught them, always with that kindness and extreme courtesy that was his hallmark.

h e never liked being present at clients' fittings, but the few accorded that honour adored him, and some even became close friends. One of them, Pauline de Rothschild, talked of his ability to influence the looks and outlook of the women he dressed. Gloria Guinness, a long-standing friend, lent the dresses she wore fluidity and grace, while the Duchess of Windsor gave them wit. Other ardent admirers included Mrs Biddle, who sometimes ordered as many as eight dresses in a single day (thus almost single-handedly keeping busy an atelier of forty workers) and the Countess Bismarck, whose beauty and elegance were legendary, and who remained in her room for two days when she heard the master had decided to close his business. Though essentially solitary, Balenciaga had many friends, among them Madeleine Vionnet, Coco Chanel and M. L. Bousquet, whom he visited regularly in his latter years. Between collections he would retreat to Spain and meet up with old friends, to whom on occasion he confided how exhausted he felt, how burdened with work and responsibilities. He once told the painter

Miró, 'You are lucky. If you want to produce a masterpiece, you do it on your own. I need five hundred people to do it . . .'. And yet he always spoke passionately about his craft.

t he year 1968, a time of social upheaval in France, was the date of the master's last collection. Experiencing the sea change that had taken place in life and society, Balenciaga saw that the time for luxury and elegance was past. Closing his fashion house filled him with profound regret and plunged his staff into a state of confusion. 'Balenciaga decides to quit – and fashion will never be the same again,' wrote Sam White in the *Evening Standard*. A private man with a horror of publicity, journalists, photographers and society chit-chat, he kept his life shrouded in mystery – which, paradoxically, was the best publicity of all.

He retired to his house at Igueldo near San Sebastián in Spain, the Spain that in a certain sense he had never really left, and whose influence had remained paramount throughout his career. It was the source of those blacks and browns, those embroideries heavy with jet-encrusted trimmings, the brilliant whites, the graceful Infantas, the austere duennas, of black lace suffused with pink, of heavy stiff silks used in big asymmetrical gowns à la Zurbarán, of the Madonna-like purity of dresses flaring into the shape of a trapeze, unyielding as statues. Balenciaga died in 1972 at Javea and was buried in his native Basque country – whose reserved character, discipline and dignity he had surely inherited.

Cecil Beaton found a fitting epitaph for this legendary couturier, whose influence extended across the whole world: Balenciaga had, Beaton said, 'created the future for fashion'.

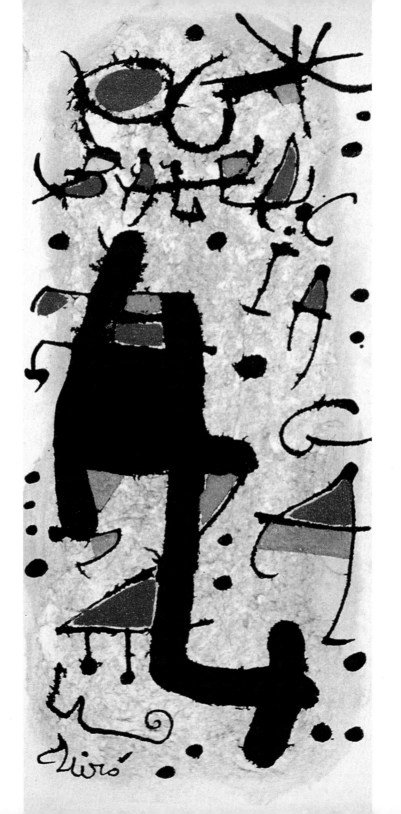

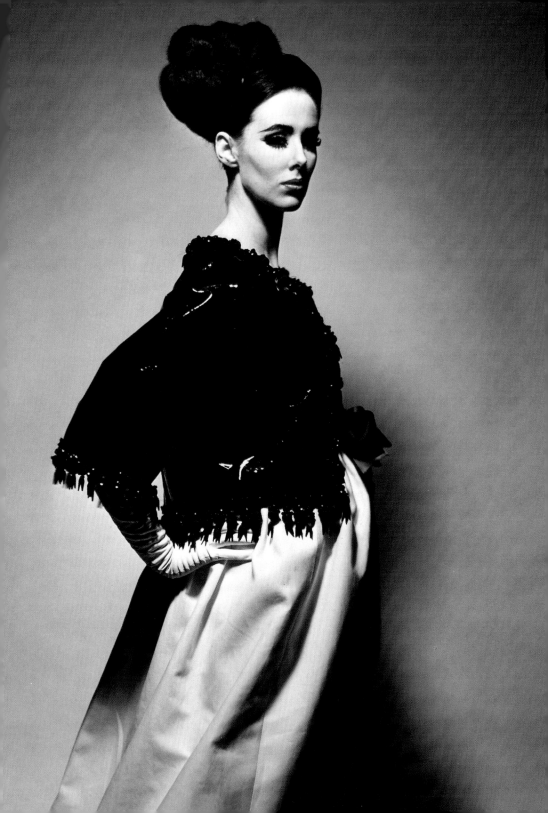

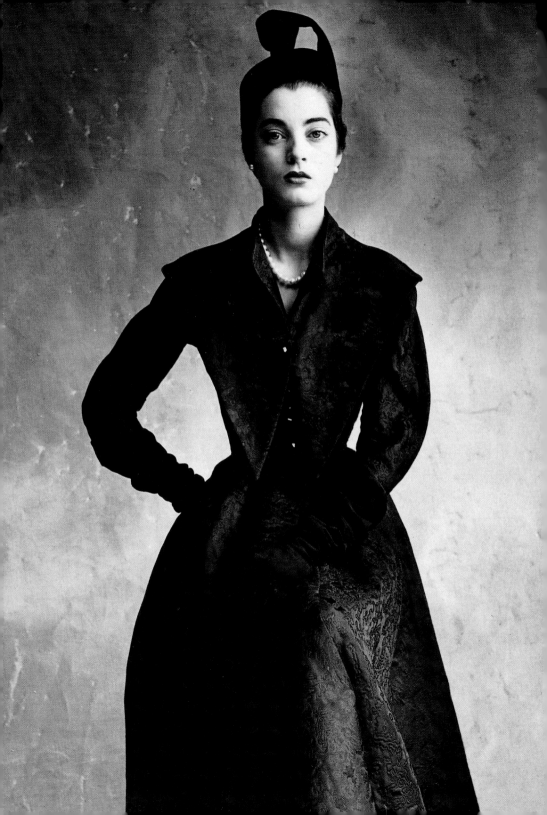

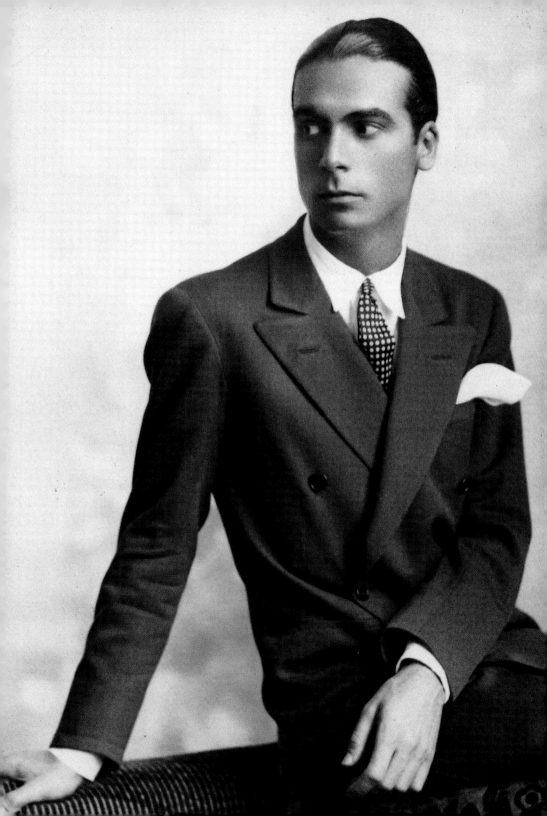

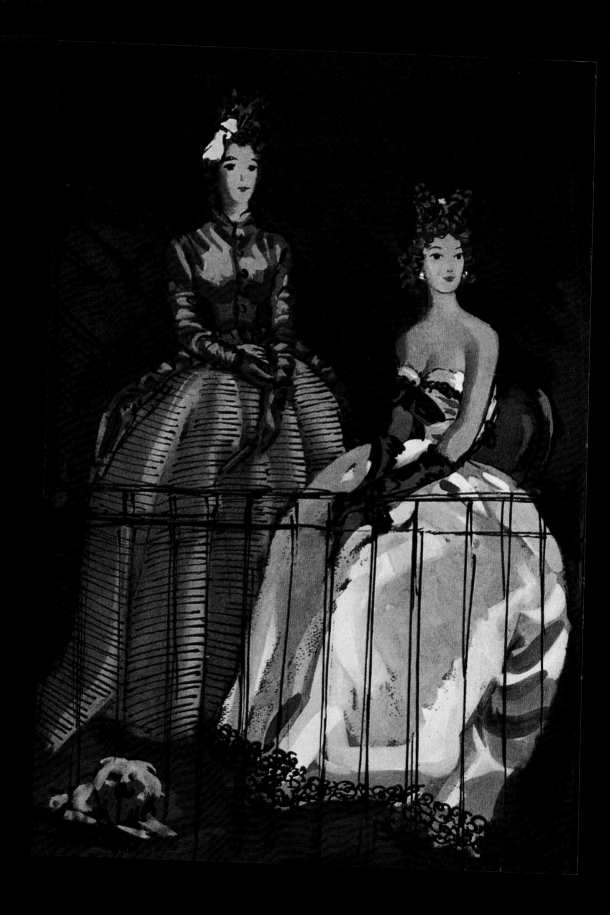

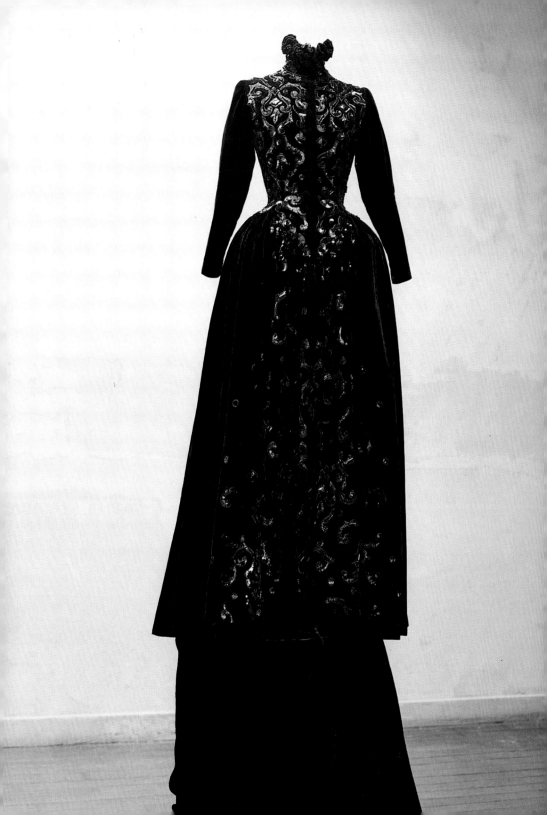

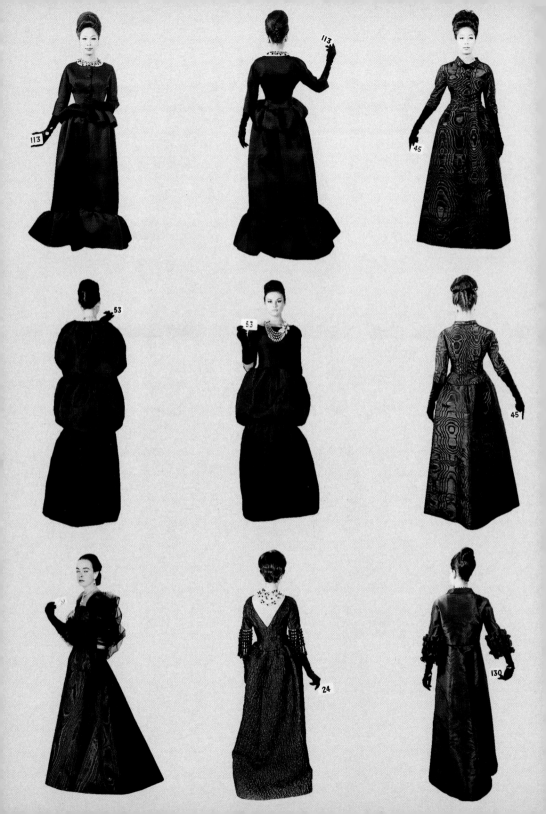

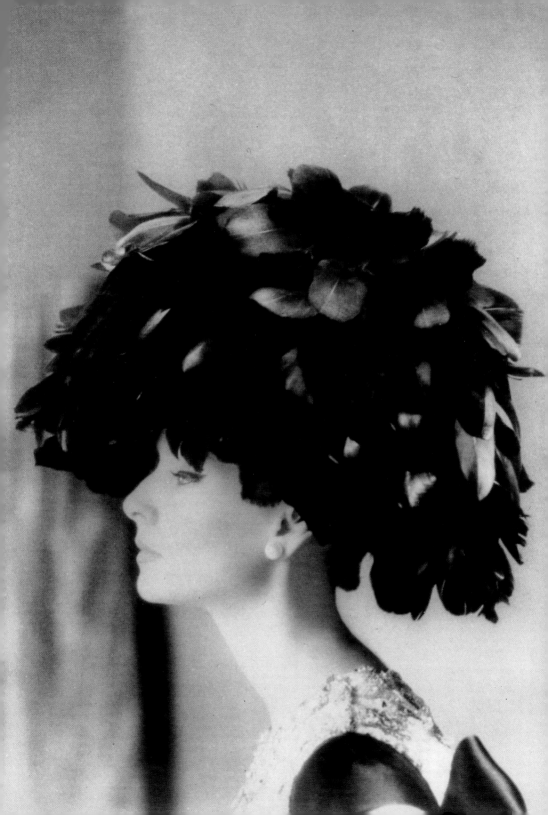

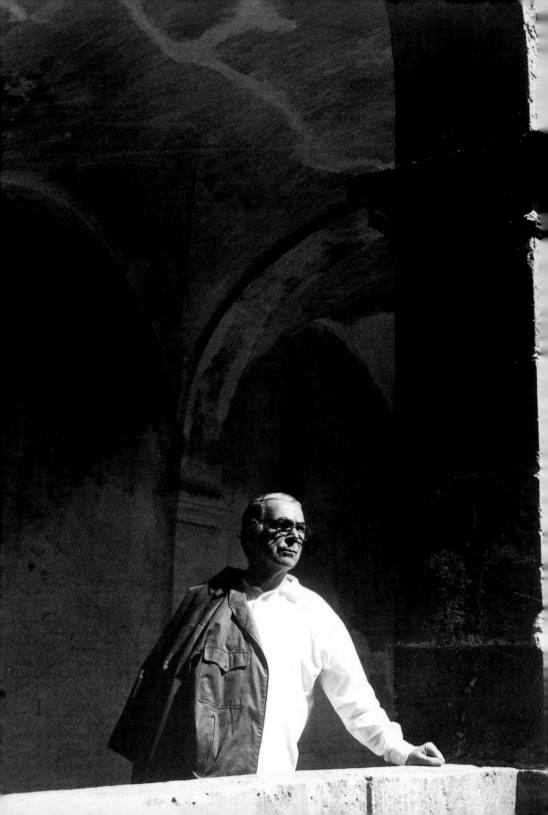

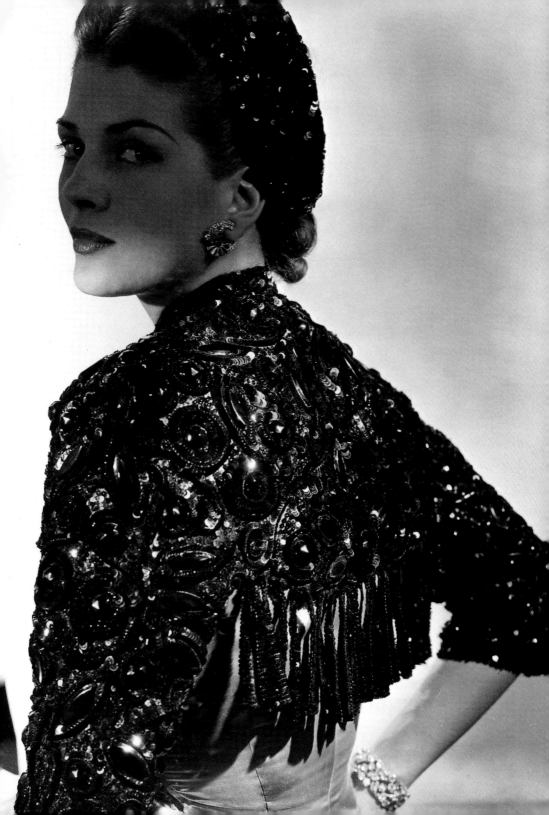

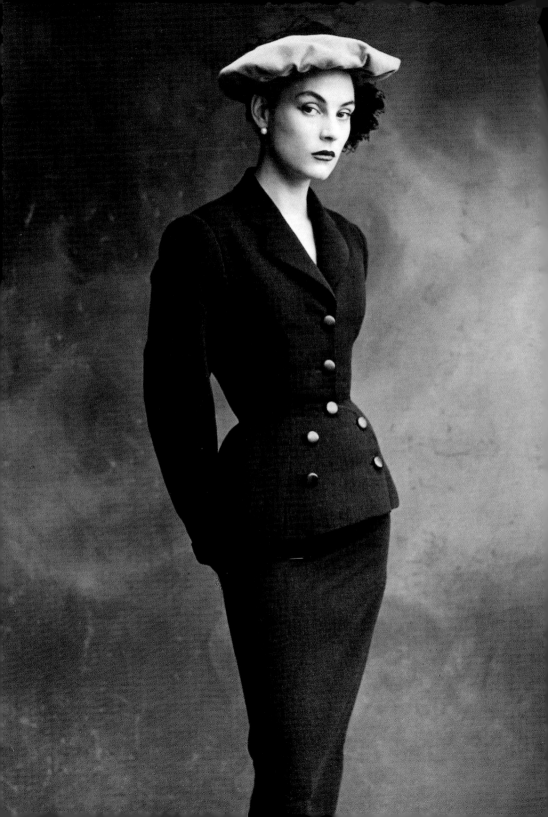

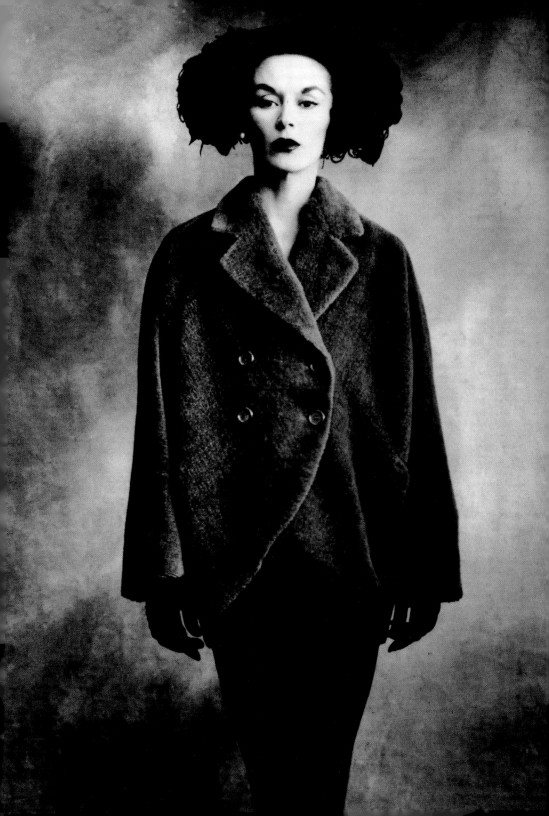

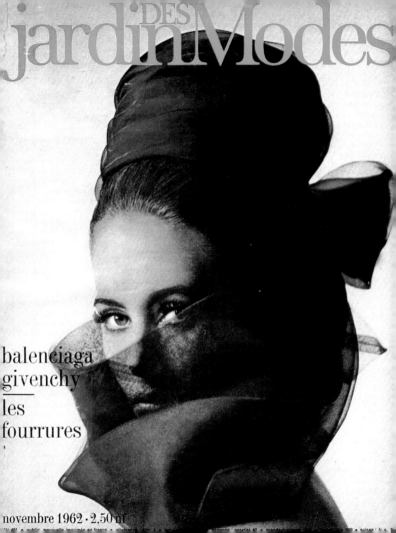

jardin DES Modes

balenciaga
givenchy

les
fourrures

novembre 1962 · 2.50 nf

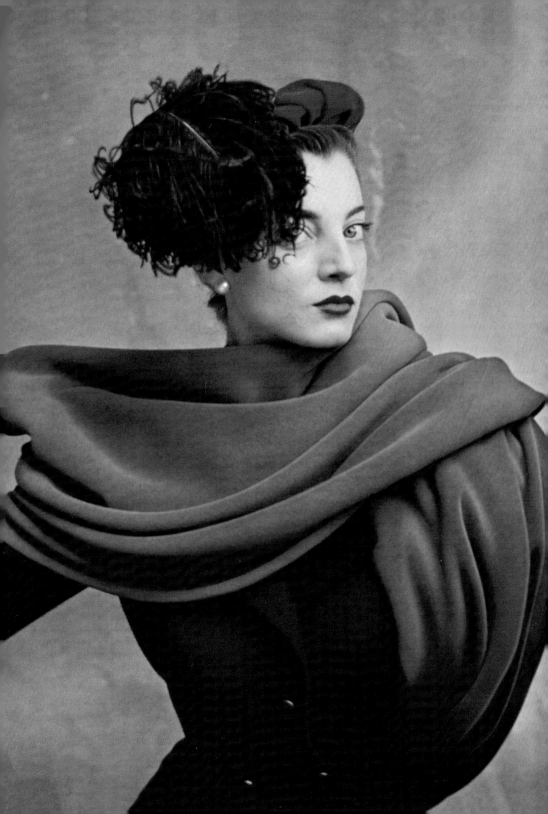

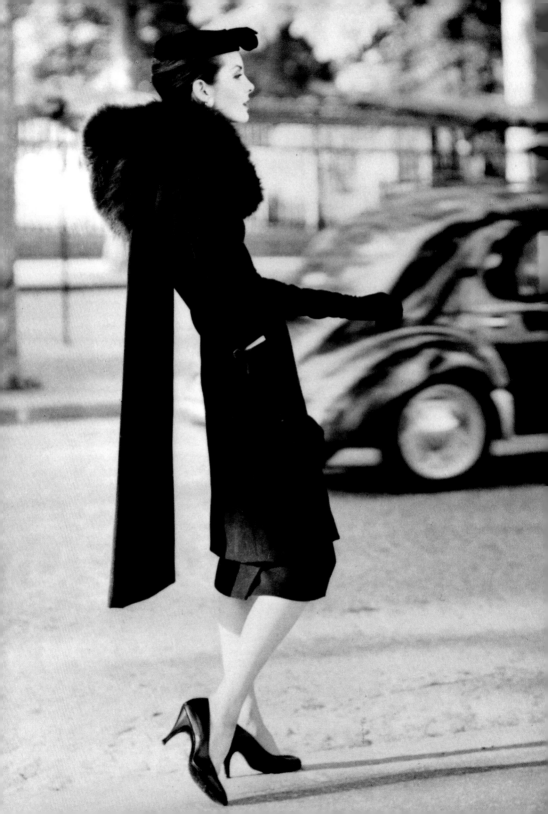

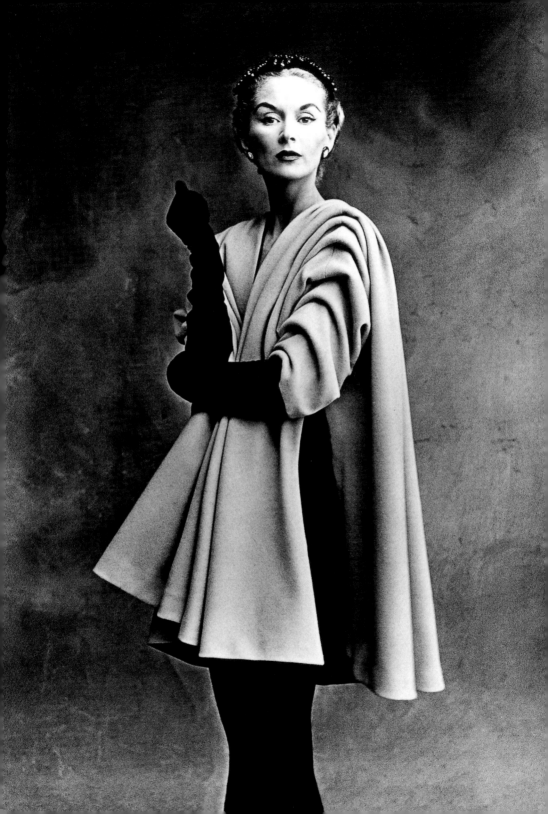

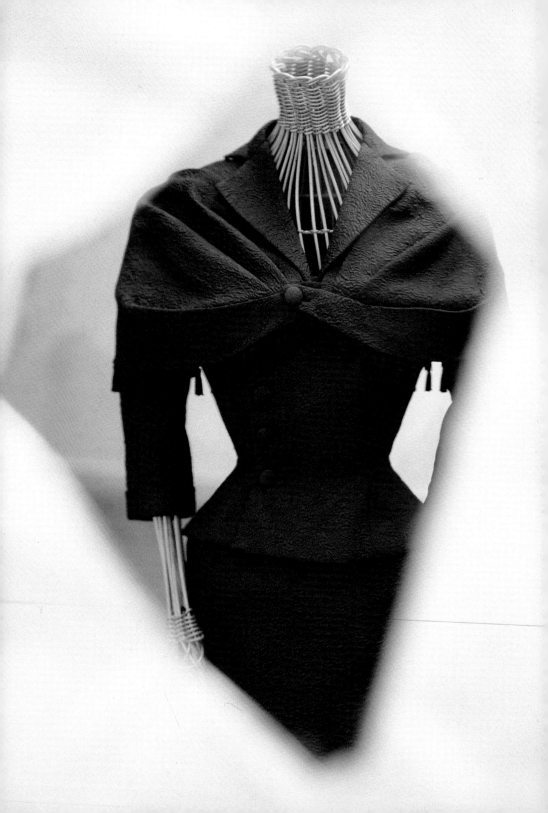

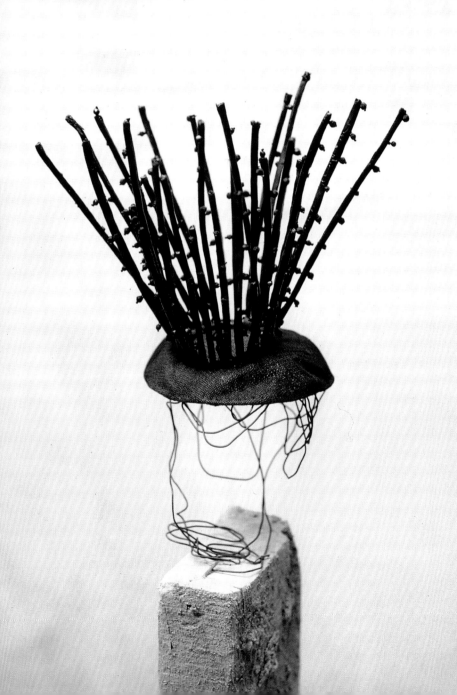

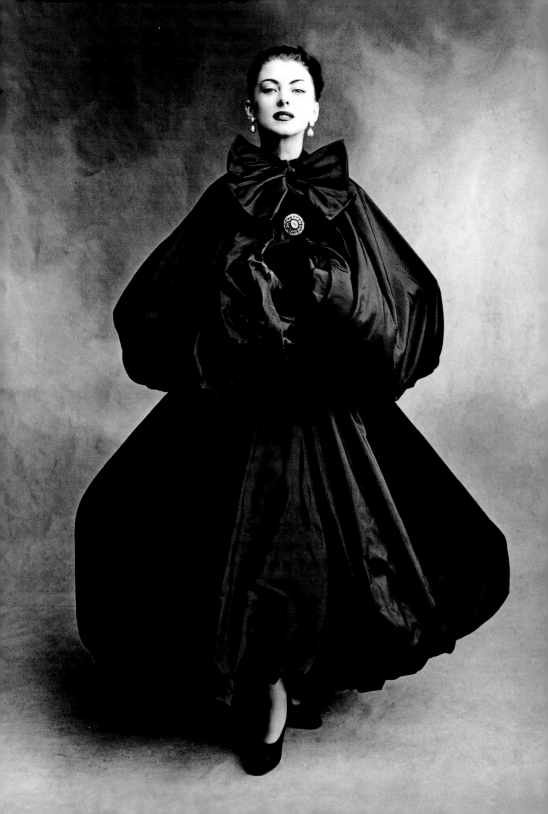

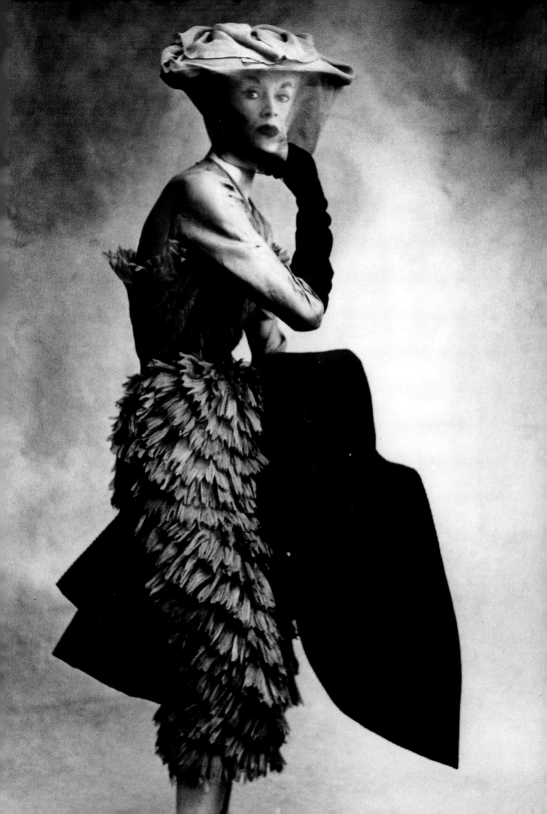

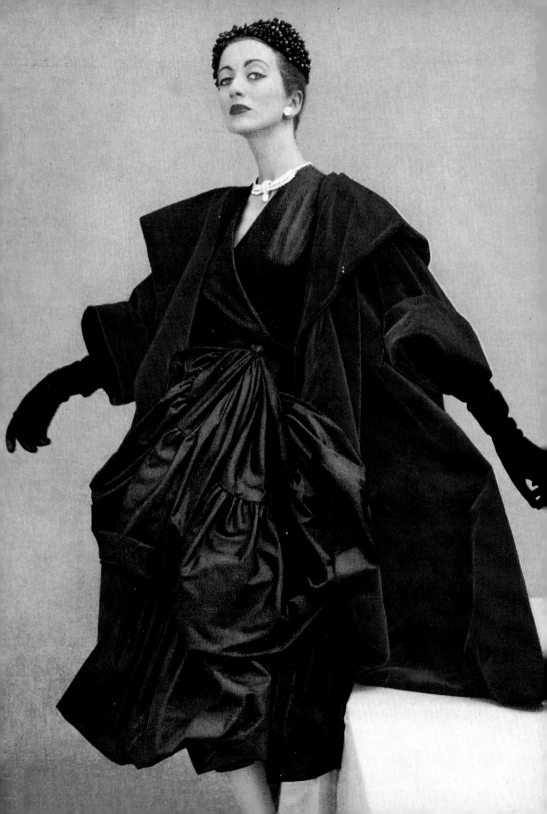

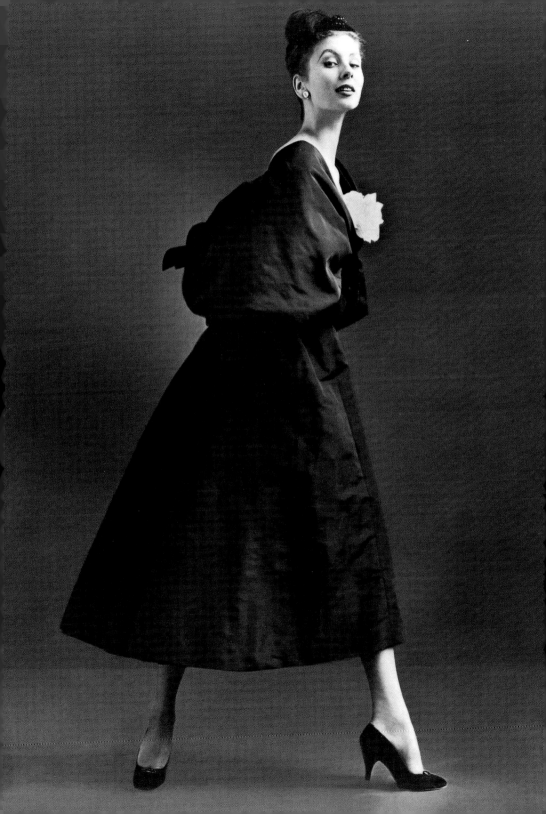

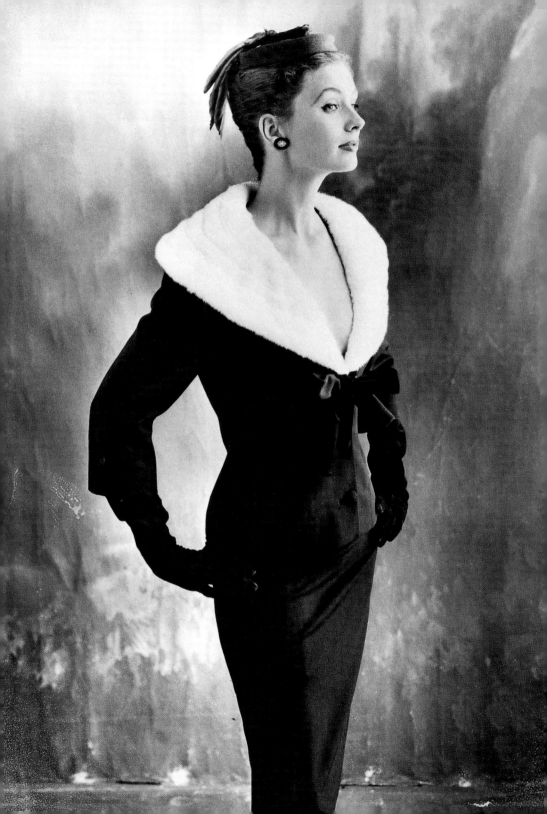

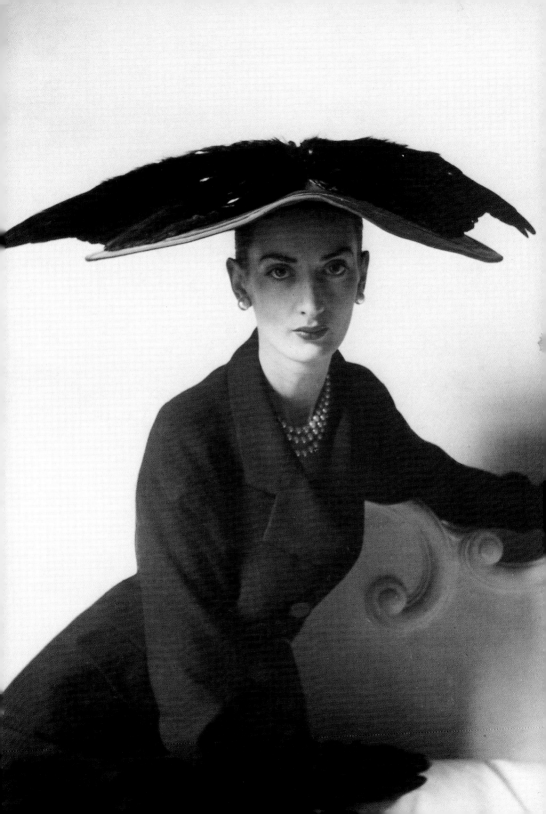

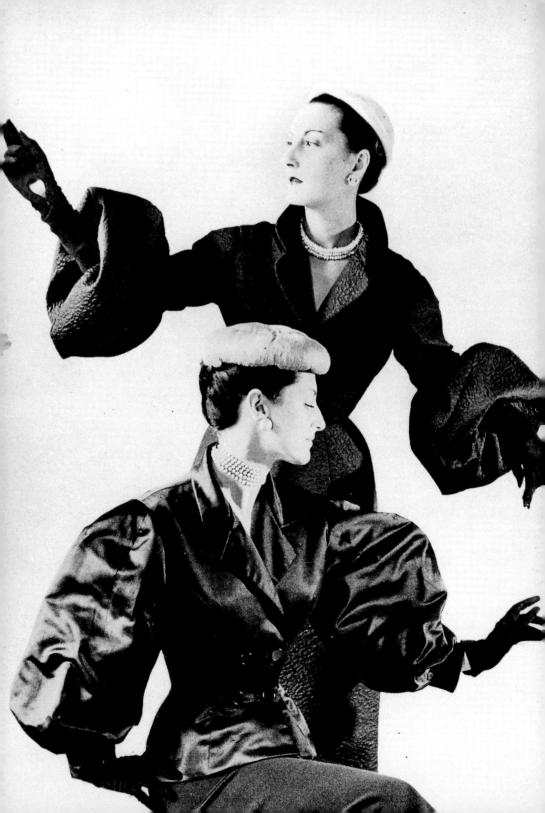

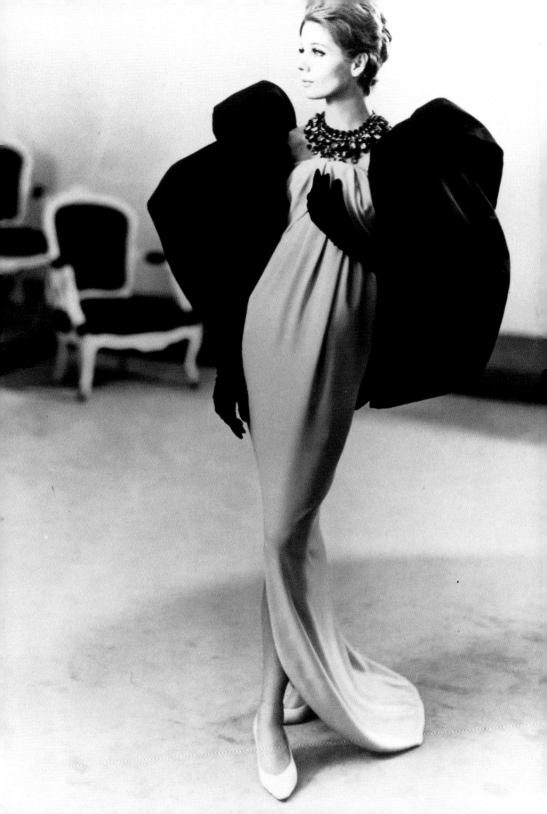

1961

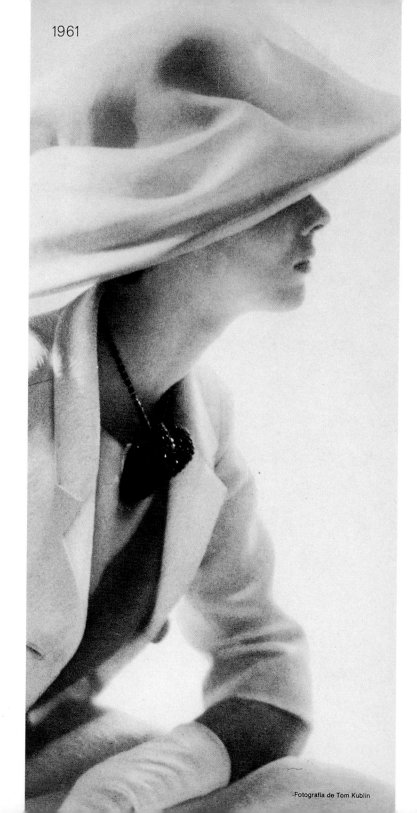

-Fotografía de Tom Kublin

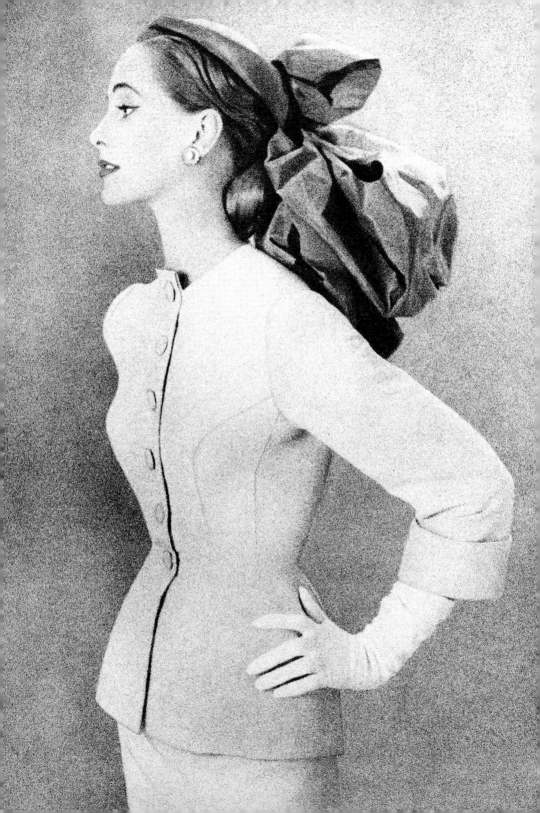

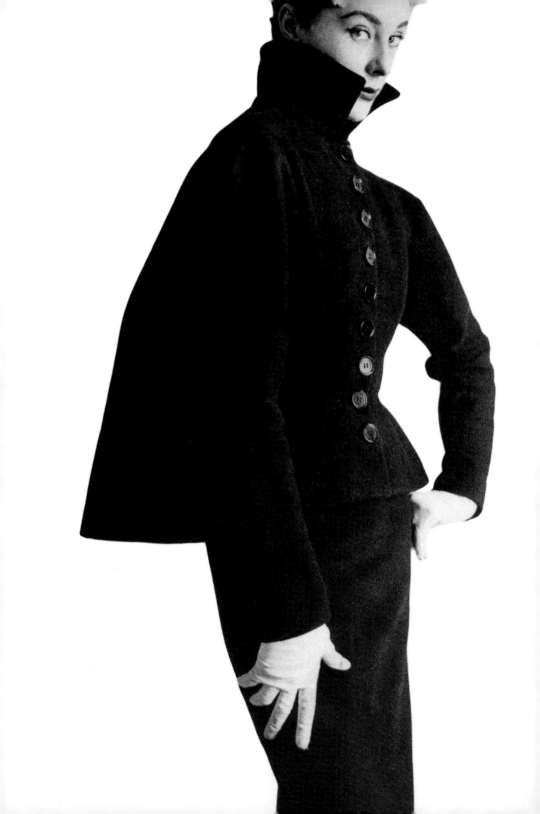

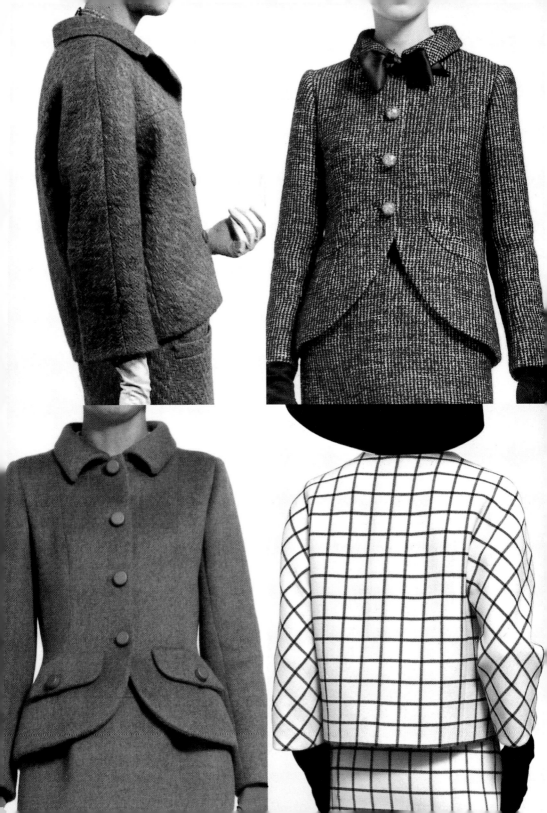

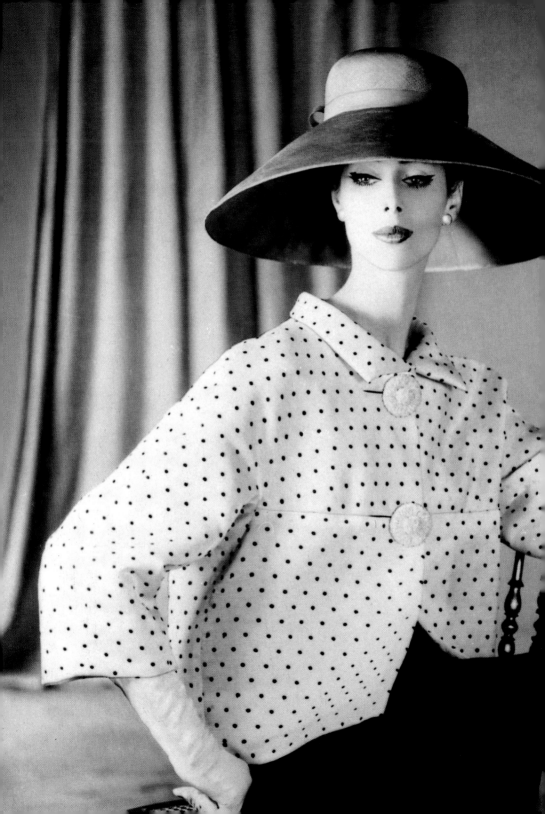

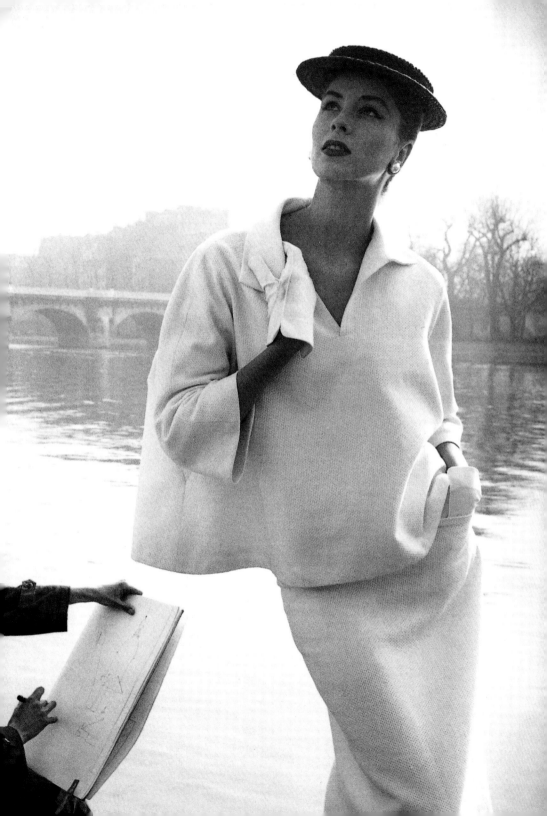

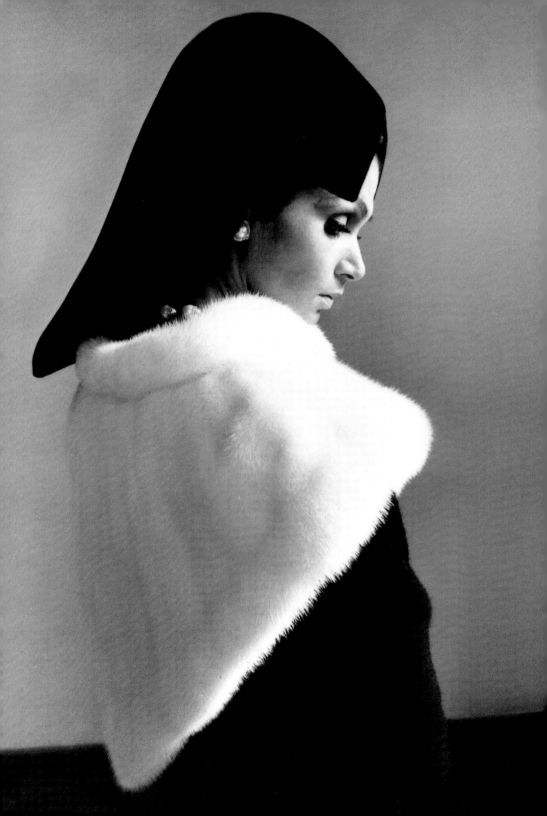

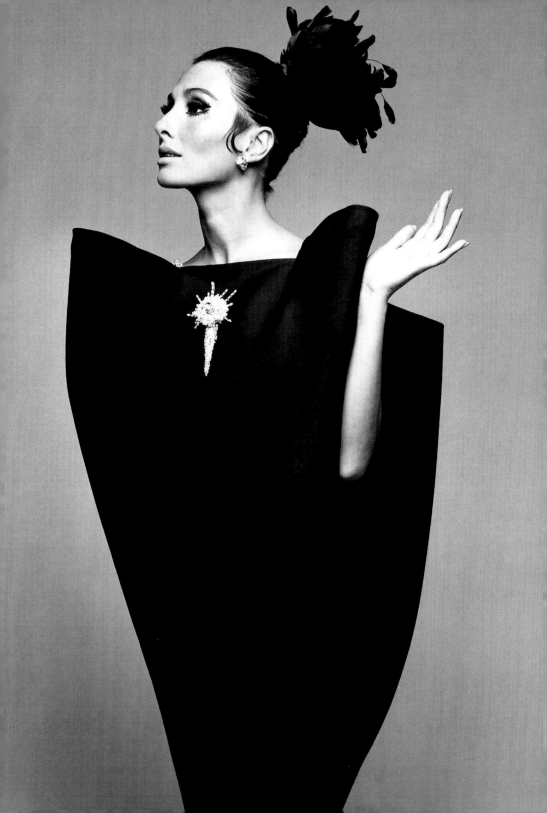

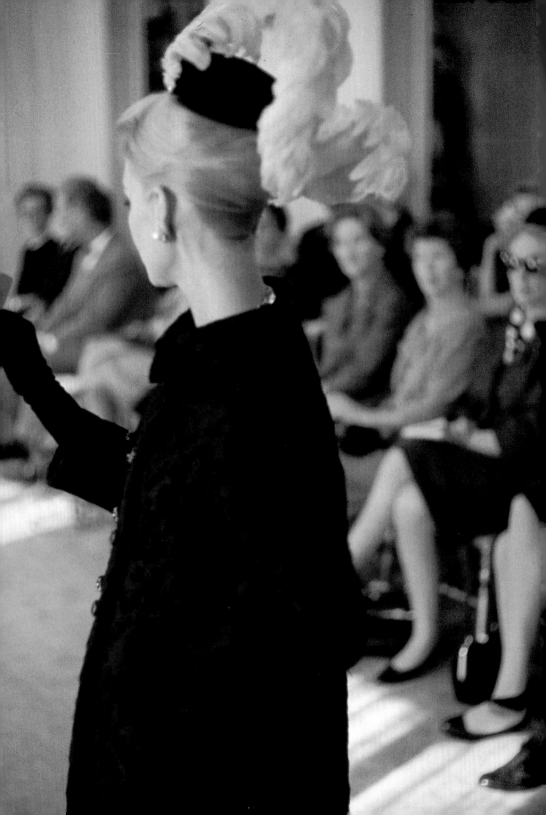

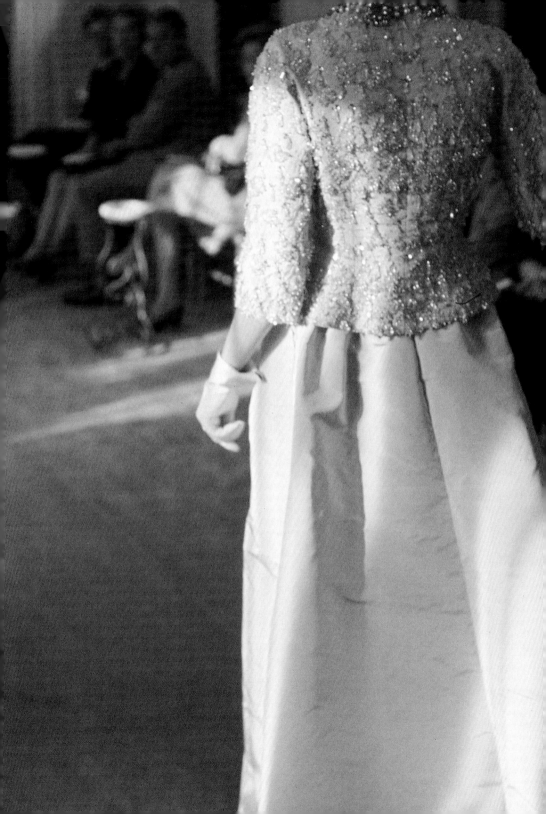

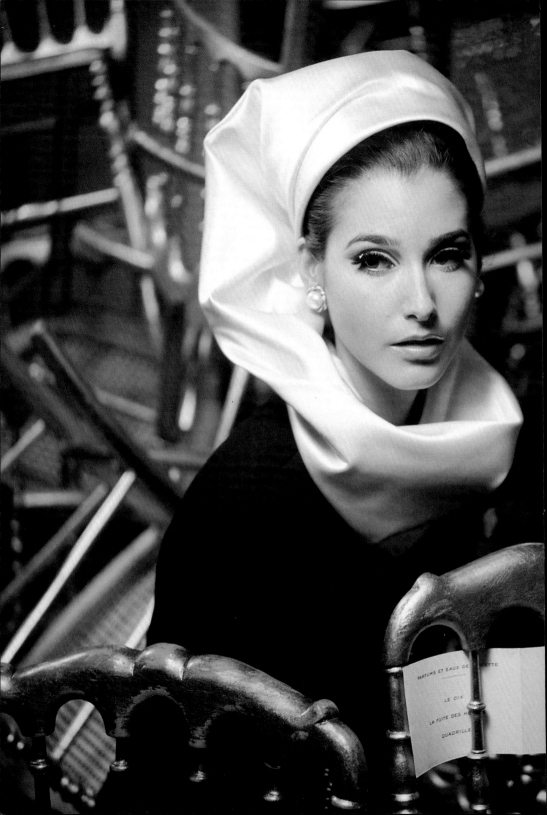

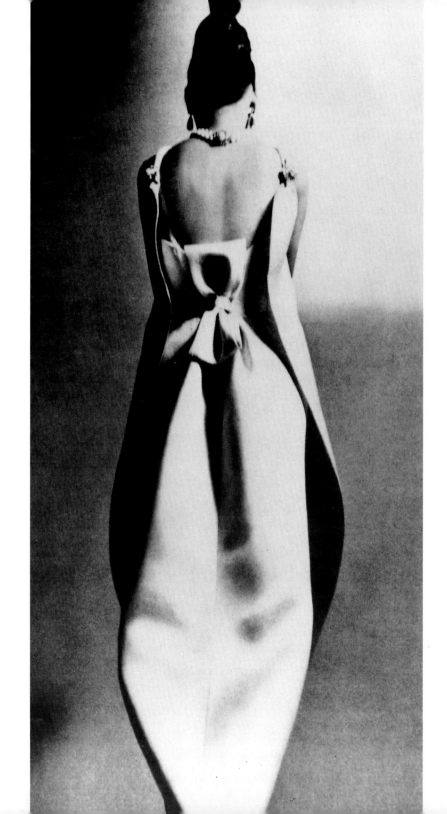

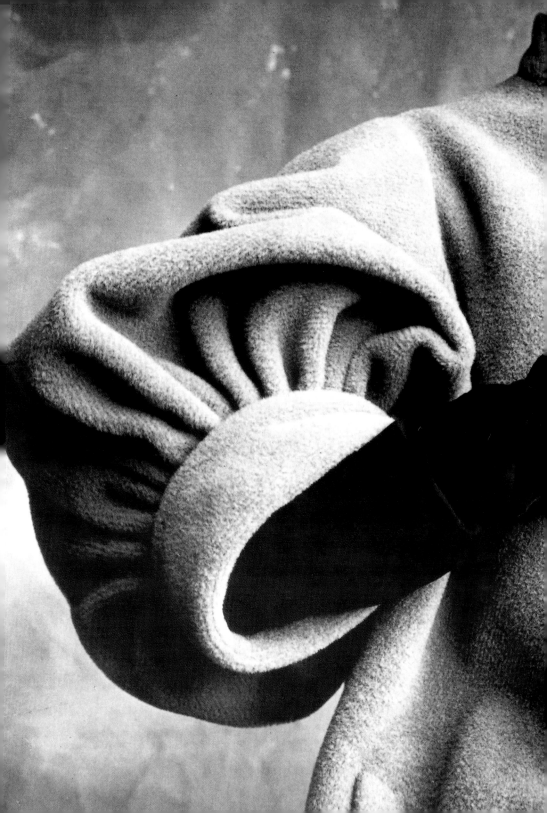

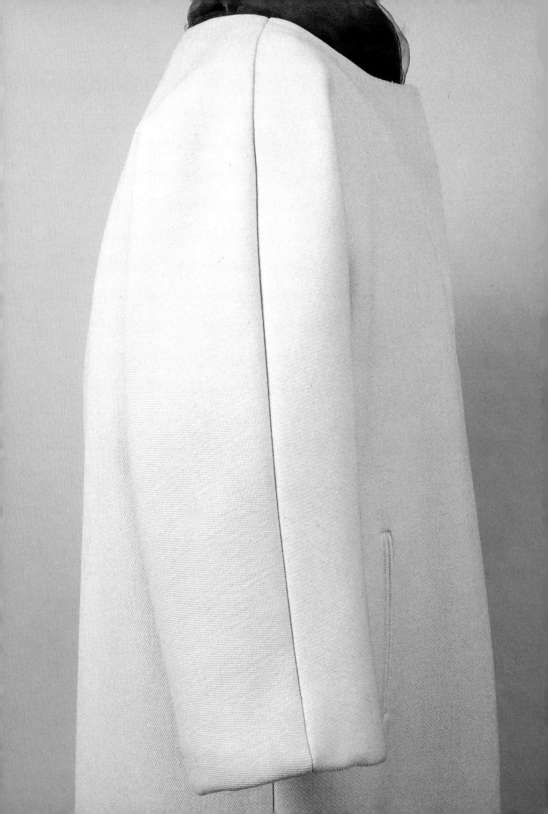

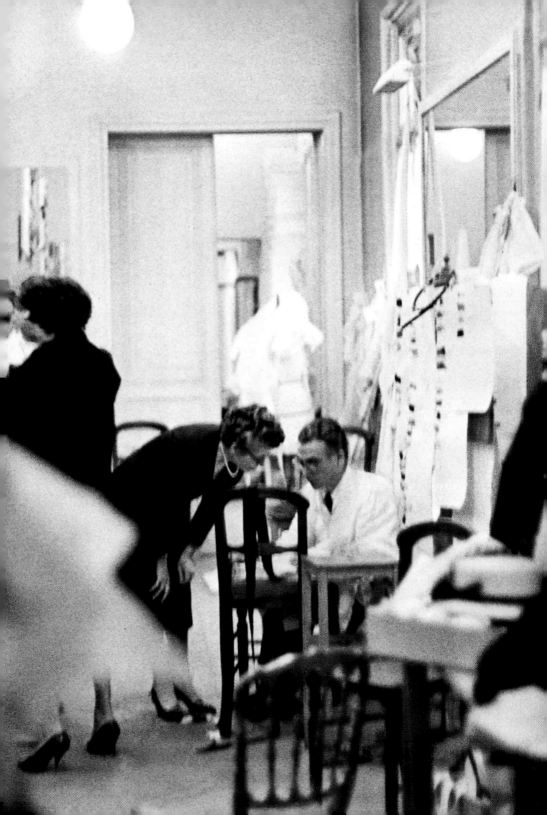

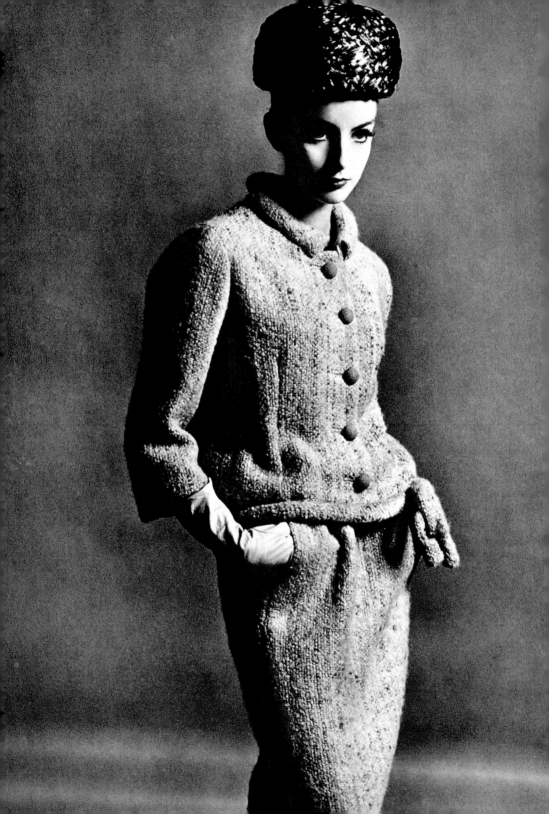

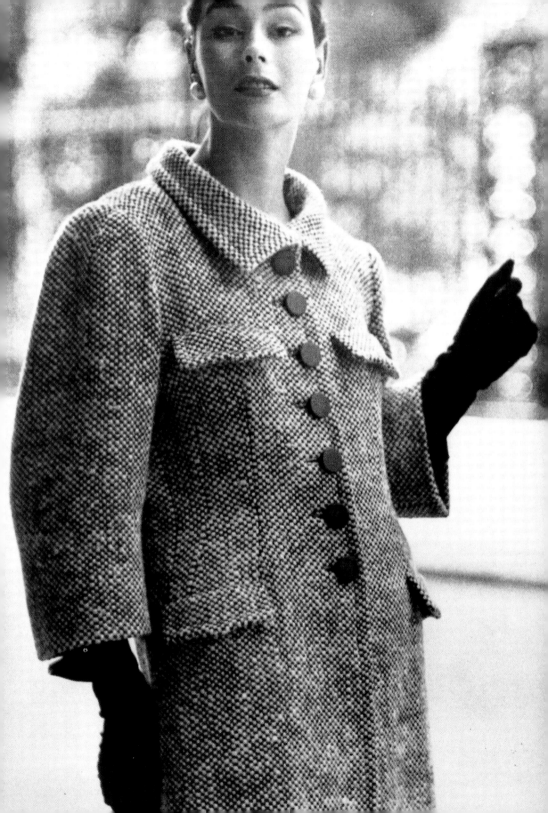

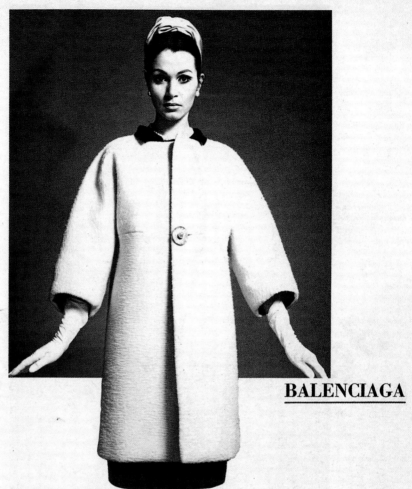

BALENCIAGA

Draperies quadrillées, écossaises, de tons vifs et inattendus, mais aussi des beiges, des marines et du blanc. Retour du noir pour les robes et ensembles ; en toile ou en crêpe de soie, elles sont enroulées, sous le dos décollé se glisse une ceinture.

Manteau à manches raglan, aux épaules généreuses et hanches minces en un lainage bourru, blanc. Un peu plus haut que la taille, un seul bouton concave, en nacre, dans lequel se niche une perle. Le col de la robe de toile noire se retourne sur le manteau. La robe, en toile de lin est coulissée à la taille, ainsi que les hautes poches poitrine. La ceinture est en linon glacé

avril/mai 1967

3

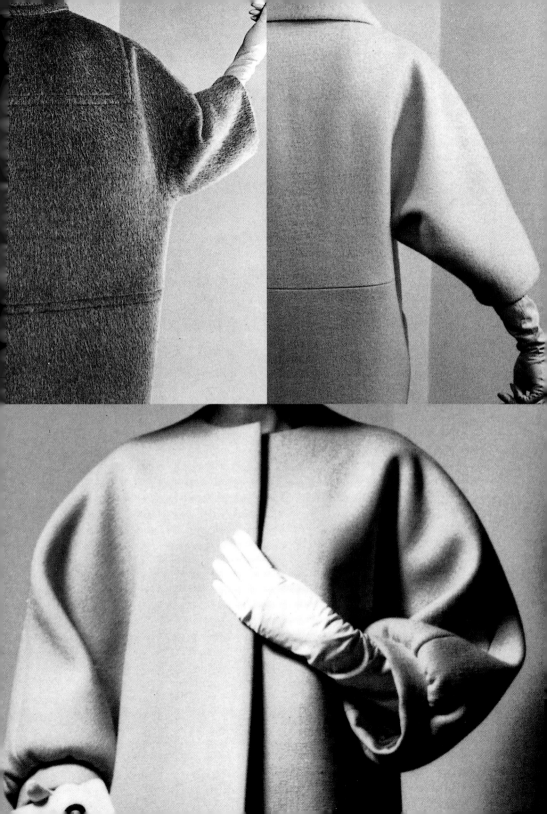

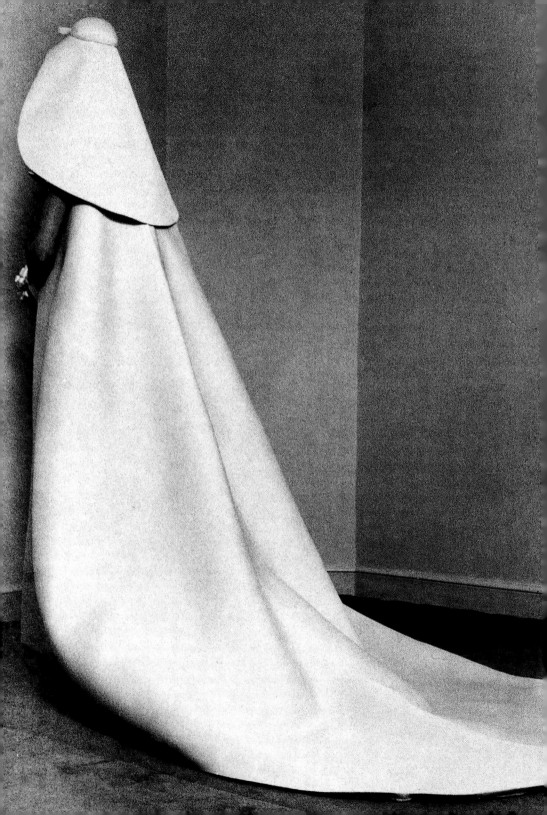

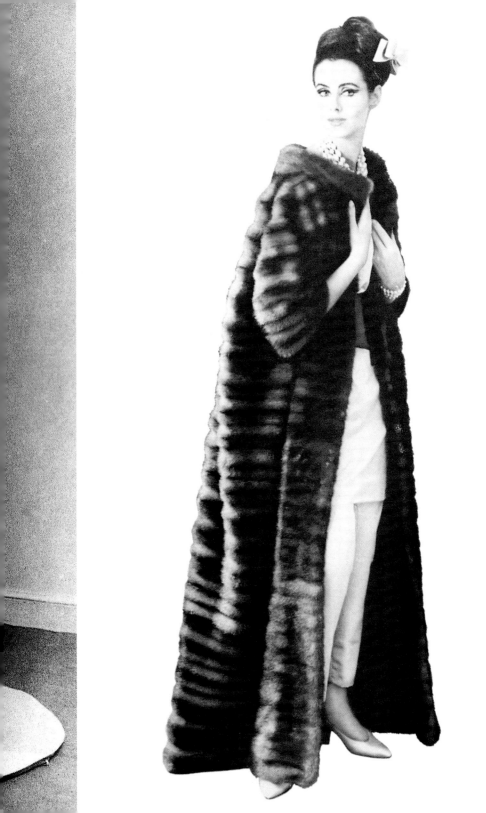

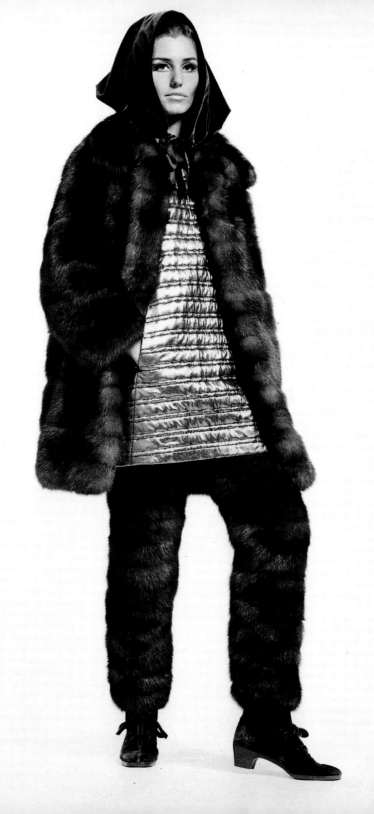

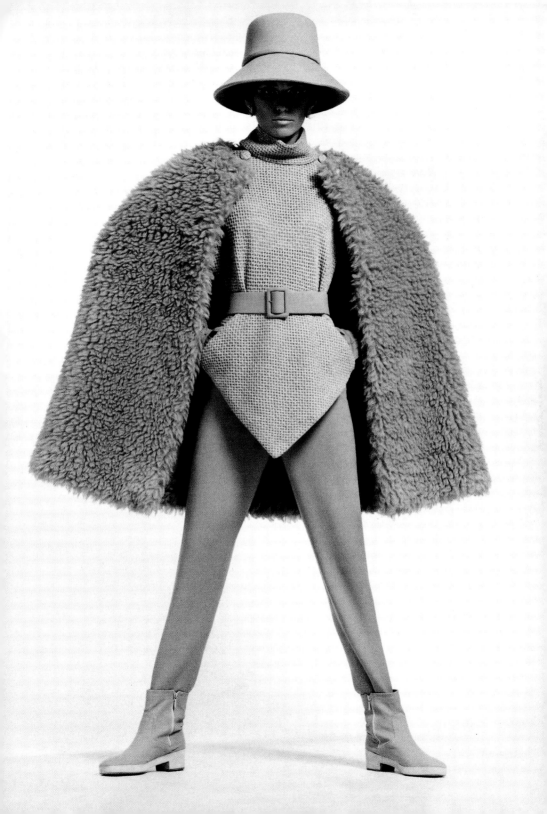

Balenciaga's Techniques Are Still Unmatched

By GLORIA EMERSON
Special to The New York Times

PARIS, Feb. 2—One of the best things about a Balenciaga collection is its familiarity. Any Balenciaga show, like his new spring-summer collection this morning, is largely a rerun of those famous, big, carved shapes that mean Balenciaga—and only him.

But Americans are made restless these days by reruns (except in the case of "Gone With the Wind"). They want to be distracted and they need to feel young.

So Balenciaga's new collection, which probably shows the best clothes in the world from a technical point of view, not an emotional one, made people restless. The New York buyers went this week to see it, but they didn't buy as much as they should have. Their customers back home want clothes that will make them look young, younger, youngest.

The youngest women at the press show today, who were in their 20's, also looked a little puzzled by Balenciaga's long tunics, the severe suits with a minimum of seams, all his

be much
d to try
le coats
woman
he same
inches,

g shoul-
ving lines,
hite in
button
ine has
re new
d them.

cuffed
w the
shorts
ement
y and

Balenciaga leaving his house at 28 Avenue Marceau with his chauffeur.

waist, and has a typical curved stand-offish skirt.

Lots of Balenciaga's sleeveless dresses with camisole tops and gentle little waists are covered up this time with brief, button-in-the-back jackets that have the deep but brief batwing sleeve he loves. Unless she is suffocating, a woman would be a fool to ever take off that little jacket. About 40 years of genius were needed to whip it up.

There is new jewelry in the show: a huge heart hanging by a chain worn with narrow red and white striped pajamas and a sleeveless top; a serpentine gold necklace, and drop earrings that surely measure four inches.

Balenciaga has always believed in lace and ribbon, the right flounce and the right ruffle, but in a very restrained and profoundly Spanish way. His prettiest dress for summer has deep and stiff flounces low on the wrists and a flounce at the hem.

Those long, sleeveless dresses with hardly any bosom and the indented high waist are back at Balenciaga, but he's made a pale blue silk version look very different, indeed, by its demi-sleeves. The sleeves don't start from the shoulders, but about four inches down on the arms, where reddish organdy petals are shaped like leaves that flutter madly down to the organdy cuffs.

Innovator of Guessing Game

Balenciaga started this whole peek-a-boo guessing game in fashion with his see-through dresses and with the bared midriffs. There are bared midriffs again—mind you, its only an inch or two that shows—in some of his most smashing evening dresses.

The evening dresses are not all emks of art. There's a covered with organdy that doesn't quite meet kirt with a slit. Just a ony shows.

gh-it-or-don't-I dress
Balenciaga collection
is time of streamers,
ows of oval-shaped
idery that stay close
olored organdy until
the streamers fly
ed the idea in long
different colors, in-
clear pink.
blue, sequined tunic
trousers that are

Balenciaga and Givenchy: Pacesett

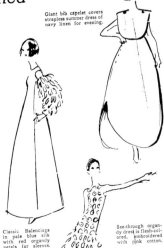

Giant bib capelet covers strapless summer dress of navy linen for evening.

Classic Balenciaga in pale blue silk with red organdy petals for sleeves.

See-through organdy dress is flesh-colored, embroidered with pink cotton.

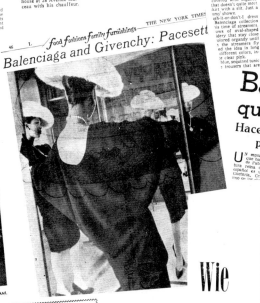

PICTURE TAKEN IN PARIS BY HATAMI.

Balenciaga, el m
que ha conquistado el
Hace un cuarto de siglo se establec
pero el gran público sigue sin c

UN español será el modista que haga el traje de novia de Fabiola de Mora, la futura reina de los belgas. Este español es un guipuzcoano de Guetaria, Cristóbal Balenciaga que no se ...

edad se establece en Paris en 1937. Seguía conservando la timidez de la adolescencia. Muy pocos amigos, un desastroso francés injerto en castellano ...

"Me pasaría—dice empleando un símil taurino—lo que a un toro ante tres torer...

Wie
MODE
Mode
wird

MARIETTA RIEDERER
●

MAINLY FOR WOMEN

The great Balenciaga is still fashion's king

By PATRICIA LATHAM

THE greatest designer of them all is Spanish-born Cristóbal Balenciaga, who has been unrivalled for many a long year. His clothes are coveted, his cut is without parallel, and his beautiful sense of timing only confirms that he alone is in tune with present day needs. Were it otherwise, then buyers would not fall over themselves to see his collection: manufacturers would not trail back to Paris almost a month after they have seen the other Paris collections.

And so to-day we show you two sketches of his spring and summer collection.

So much a part of this designer's collection has always been his voluminous tent-like coats, and it comes almost as a shock to find he has dispensed with them (for this season anyway) and in their place appear cape-coats. But these are so practical and becoming that they will most certainly find favour with buyers and manufacturers.

12 months' wait

However, don't expect to find them in your favourite store or shop just yet—it will take some 12 months or more for their impact to be felt. This is always the case with good designing, and emphasises why Balenciaga's clothes are the most sought after, why you are wearing them to-day (even if they have been adapted) and why you will be wearing them to-morrow.

He follows his cape theme through into evening, adapting them here, modifying them ...

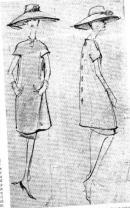

[Sketches by Crunshaw]. *Exclusive models, reproduction forbidden.*

This sketch shows the front and back of a pale pea green linen tunic dress which glides over the body. The sleeves low cut and small pockets are aslant at the front, and over

(Sohns)

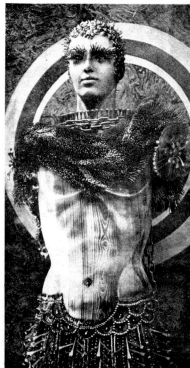

Eine Schaufenster-Plastik aus Holz von Janine Janet, benagelt mit allen Arten von Metallringeln. Der surreale Jüngling ist im Schaufenster von Balenciaga zuhause.

Féerie de haute couture au Pavillon de la France

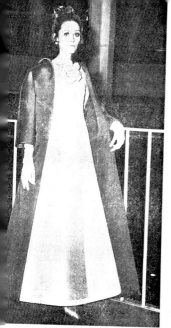

La France ne serait pas la France sans la haute couture. Son pavillon de l'Expo s'est transformé hier soir en un immense écrin à l'occasion de la présentation de mode offerte par la Chambre syndicale de la haute couture parisienne.

Une collection éblouissante commentée fort poétiquement par le comte Jean de Faucon et qui rassemblait les noms des couturiers les plus prestigieux : Patou, Dior, St-Laurent, Balmain, Givenchy, Balenciaga, Venet, Lanvin, Ricci, Grès.

Présenté au rez-de-vaague, le spectacle avait quelque chose de féerique par la somptuosité du décor et des vêtements.

Cette soirée de gala qui réunissait une foule élégante et très gaie était rehaussée par la présence d... délégué ... Delfour, Pierre D... France e... invités, Antoine Ustinov, de nom des res...

Po... choisi... plus sc... par leu... de mc... un gr...

Carmel Snow
EDITOR of HARPER'S BAZAAR — Previews
Simplicity Key To Balenciaga

● This is the second of a series of six articles by Carmel Snow, America's famous fashion expert, in which the editor of Harper's Bazaar gives her authoritative, colorful and exciting preview of the Paris fashion openings. Each article is presented with a set of photographs, illustrating the latest styles and selected especially by Carmel Snow for the N. Y. Journal-American.

Balenciaga triunfa una vez más en París
Su desfile de modelos para la próxima temporada ha causado sensación
Su triunfo es el triunfo de la sobriedad y la elegancia

SOBRIEDAD

Esta es la palabra que lo resume todo en la línea que ha presentado Balenciaga en París, el último de todos cuando ya la capacidad de todos admiración de los parisinos —y sobre todo de las parisinas— Baren...

nos han ofrecido los modistos parisinos para la próxima temporada de primavera-verano, el gran creador español ha da...

TRAJES SASTRE

En los trajes sastre, las faldas son muy apustadas y estrechas por delante y por detrás pero se animan a los lados con fuelles de dos o tres pliegues. Las chaquetas cortas, los hombros rectos, manga kimono y unas solapas nulas, destacan en las cruzan el busto y la cintura...

abrigos dejan vislumbre del traje uno de los pro... Un corte muy limpio, una gran anchura en la mientras que, por las mangas comen el se hace diminuto... los 7/8 de gruesa la la mañana o "shart a mucho vestir hay nuevo éxito, lo mis trajes — abrigo ul... totalmente abo... delante y abrigo con cuellos sas... te clásicos.

Y BLANCO

el día algunas color ponen un ...

El ordenó, y todas las mujeres le obedecieron
★ EN NOVIEMBRE, EXPOSICION DE LA OBRA DE BALENCIAGA
★ LLEGA EL REINADO DEL PANTALON VAQUERO

La moda ha muerto. Con la silenciosa invasión de tiendas de "pret a porter", en las que las señoras, señoritas y ni... fas en general, llegan, se prueban el modelito, se lo ponen y en paz, la moda ha fenecido. El complicado engrana de punse, tejidos únicos, elevadísimas cifras de sus últimas boqueadas. La Prensa U.S.A., avizor sobre la incidencia sociológica y vida, casi ha expedido su certificado de defunción a la alta, exquisita e in... canzable moda.

Ha llegado la revolución de los pantalones vaqueros, desde la princesa Ana de Inglaterra, hasta el rey Hassan II —que presidió una parada militar en pantalones vaqueros— sin olvidar a otra figura popular mundial. "El Cordobés" han hecho de los vaqueros, una prenda cotidiana. Y ello por ello, ahora mas que cuando vivía, vale con fuerza el recuerdo de un español, figura internacional de la moda, Balenciaga, al que España va a tributar un homenaje de admiración. Su colección admirada mundialmente en el Museo de Nueva York vendrá en noviembre a España.

Vestidos para la historia

El "Times" ha escrito de Balenciaga que fue "el más distinguido de su tiempo". Sus diseños y sus realizaciones son ya parte de la historia del siglo XX. Cristóbal Balenciaga, aprendió el oficio de su madre, costurera de donostiarra. El, años después, hizo ... sus ... a las reinas María Cristina, Victoria ...

interés en el que ha motivado las gestiones emprendidas por los Productores Nacionales de Fibras Sintéticas para traer a España la colección que se exhibe en Estados Unidos.

Línea y confección

Con Balenciaga, escriben los historiadores de la moda convencionales, la alta costura se "uso mas simple de línea" y mucho más elaborada de confección. Durante años Balenciaga fue el amo...

—Puede más que el Papa, Ha añor tubo un llamamiento en todos los sermones. Se decía que las faldas debían ir más largas. Muy poca gente hacía caso. Llega Balenciaga y dice: "las faldas más cortas" y de la misma noche a la mañana, y todas, al instante, protestar alargaron sus ...

Un museo para un maestro y especialmente la pervivencia del recuerdo del reinado de la moda y sus modelos ahora que han perdido su retro, lo historiadoras ya lo han certificado. "Una creación de Balenciaga representa tanto en el siglo XX como un cuadro de Nicolás de Staël, una película de Antonioni, una sinfonía de Stravinsky".

EMILIO REY

CRISTOBAL BALENCIAGA

Monarch of Haute Couture Balenciaga the Unsurpassed

By GLORIA EMERSON
Special to The New York Times

PARIS, Aug. 4—The birthday of Cristobal Balenciaga is not known. He is, perhaps, in his 71st year.

There are rumors that he is sometimes bored with doing two collection... wonders ...

do coats. In nine-tenths lengths, or slightly shorter, Balenciaga's coats still have famous hulking shoulders, the rolled ... small collars, the deep raglan sleeve... the loose big bodie...

Balenciaga 'Still The Master'

PARIS (UPI) — The Paris spring fashion parade ended with buyers agreeing that Cristobal Balenciaga still is the world's best dressmaker.

Balenciaga displayed his 1963 spring line to buyers only as is his custom.

Buyers who saw the show praised him as "still the master," said his contributions to changing styles were not radical, but included emphasis on shoulders. His dresses and sleeves were ... stin dresses and nearly ...

suit jackets were slightly longer, to mid-hip or below, and loose in back and only slightly fitted in front.

Suits had narrow leather "dog leash," or cord belts, that have appeared in many collections.

His afternoon dresses and chiffons, many printed silks and chiffons, had sleeveless or with tiny cap sleeves," and man in waistless "sack" style. He also showed slim black crepes for evening. When belts appeared, they usually were slung loosely at sip-level.

The buyers said Balenciaga's ...

The show-stopper was a floor length coat of leopard fur — over black berets pajamas.

"The buyers also applauded Balenciaga's new look in raincoats. A much unstrapped gold buttons on the shoulders of one navy blue raincoat, and a black cape came off to turn the raincoat into a raincress with a Peter Pan collar.

Earlier Yves St. Laurent, the off-beat designer of Paris, showed a controversial spring collection.

St. Laurent leaned heavily on his last season's "Norman Fisherman's blouse," which may ... have inspired all U...

EVENING STANDARD FRIDAY APRIL 26, 1968—7

SAM WHITE'S PARIS
Balenciaga decides to quit—and fashion will never be the same again

PARIS, Friday.

NEWS reaches me that Cristobal Balenciaga, without doubt the greatest dress designer in the world and the only authentic genius among Paris couturiers, is planning to put up his shutters and retire from the fashion business.

In fact, it is unlikely that he will exhibit in the Paris July-August shows this year, Balenciaga, 73, a Spaniard, opened his Paris house in 1937, and ever since, despite the War, despite the rise of Dior, Fath and Yves St. Laurent, he has remained in a class of his own and the ultimate arbiter of taste. No one could match him in skill, inventiveness and perfectionism.

For him to remove himself from the Paris fashion scene ...

AN ENVOY IN THE BOUDOIR

BARON Marcel-Henri Bonnet ... there is an ambassador I admire. He was Belgian Ambassador in Paris from 1955 to 1960. Now 67, he has published his memoirs in Paris under the simple title of Bouveriers, the book was in process of being published it was announced as a work reflecting on his distinguished diplomatic career and containing some important political revelations concerning his seven crowded years in Paris, instead of which the book turns out to be an updated version of Frank Harris's Life and Loves.

DIPLOMAT

There is, of course, the usual diplomatic discretion but it only applies to his work as a diplomat and not to the diplo... so it is longer ...

..., The first to rightly coloured patterned tights ave now become and can be bought

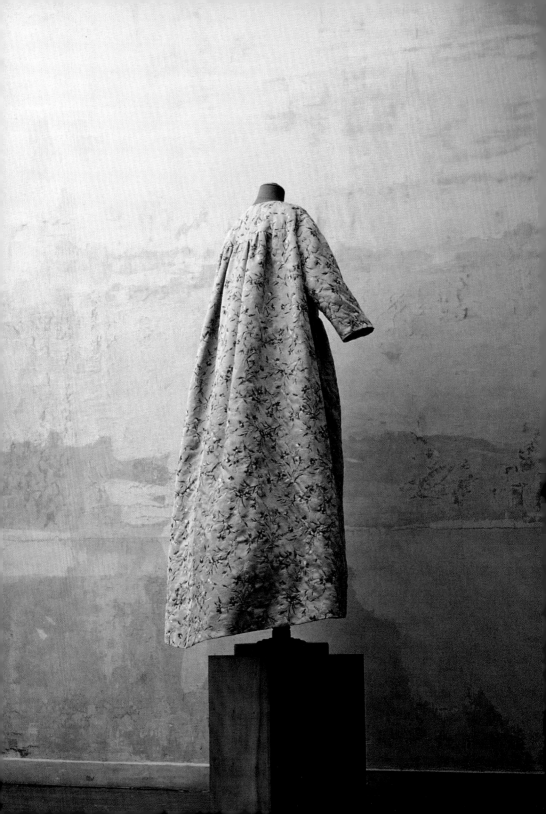

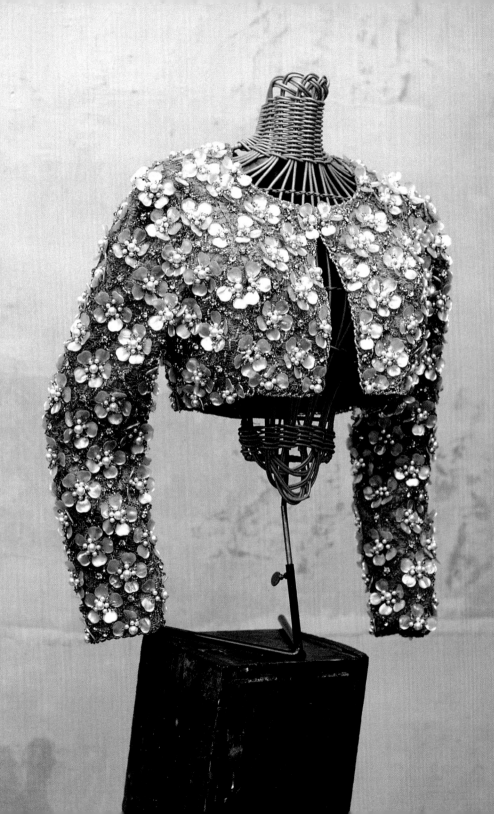

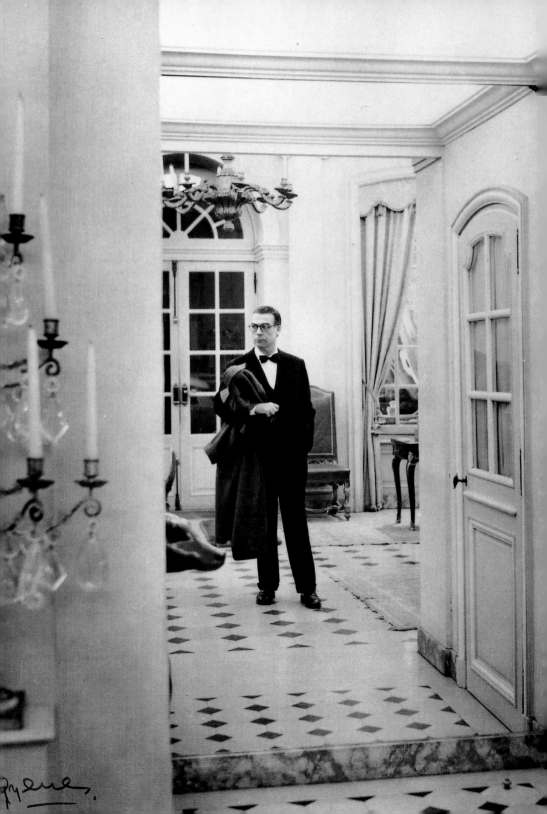

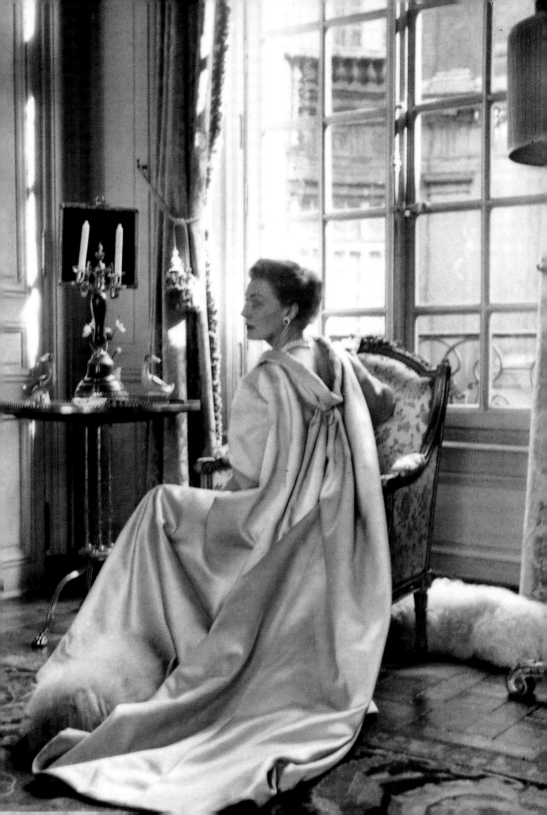

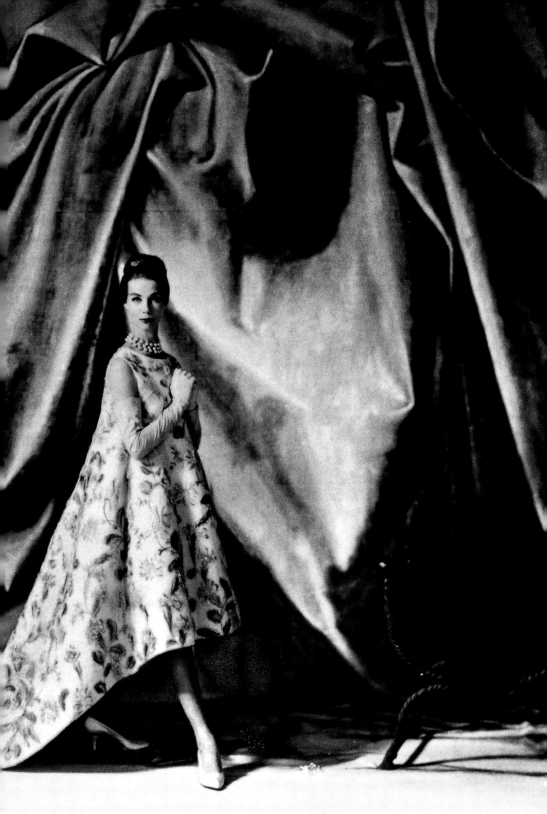

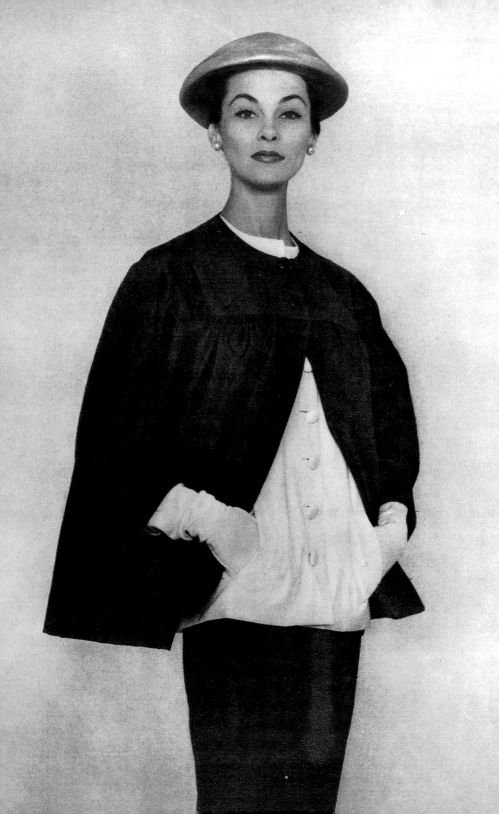

Chronology

1895 Born in Guetaria in the Spanish Basque country.
His mother, a dressmaker, teaches him to make clothes at an early age. With the encouragement of his patron, the Marquesa de Casa-Torrès, he trains as a tailor in San Sebastián and Madrid.

1913 Employed by the shop 'Louvre' in San Sebastián, he rapidly rises to the top.

1919 Opens his first fashion house in San Sebastián, under his own name.
Dresses the royal family and travels frequently to Paris, becoming known among the couturiers as a regular customer.

1931 Fall of the Spanish monarchy. His clientele changes and, as a mark of respect to his mother, he renames his business Eisa.

1933 Opens a second fashion business in Madrid, under the name Eisa.
Dresses the Spanish aristocracy.

1955 Opens a third outlet in Barcelona.

1936 Outbreak of the Spanish Civil War. All three fashion houses are closed. Seeks safety in London and tries to find employment with Worth and Maggie Rouff.

1937 Goes to Paris and meets up with friends from San Sebastián. With their help, opens his fashion house on the Avenue George V and presents his first collection. An immediate hit with the buyers.

1938 The three Spanish fashion houses are reopened.
In Paris, the press enthuses over Balenciaga's little black dresses.
Creates the dresses worn by Hélène Perdrière in the film *Trois de Saint-Cyr*.
Dresses Lucienne Bogaert, both for the stage and as a private customer.

1939 Purchases the adjacent premises from the couturier Mainbocher and expands his business. People fight to get into the collection; the press runs the story.

1940 Smaller collections for a private clientele because of the war.

1941 Magnificent dresses inspired by the Spanish Renaissance, worn by Alice Cocéa at the Théâtre des Ambassadeurs. Nine dresses for Hélène Perdrière at the Théâtre de la Michodière.

One of Cristobal Balenciaga's revolutionary designs: a collarless blouse-jacket in black shantung, over a long waistcoat of white piqué. Summer Collection 1951, Denis's atelier. Photo: Rawlings. © All Rights Reserved.

1943–44 Emphasis on hats. The famous milliners Legroux Sœurs start to work for the house.

1945 The House of Balenciaga takes part in the 'Théâtre de la Mode', with clothes modelled by dolls wearing the famous chignon created for Balenciaga by Guillaume in 1944.
Design of the costumes for the San Sebastián Choir, modified in 1964 and still worn today.

1946–47 Launch of the barrel line and of embroidered boleros inspired by the toreador's costume. First Balenciaga perfume, 'Le Dix'. Opening of the fashion house Christian Dior and arrival of the New Look.

1948–49 Major collections. Carmel Snow writes of the huge success he enjoys with his private clients. Opening of the Balenciaga shop at Avenue George V; the decoration is by Cristos Bellos and its famous windows, the talk of Paris, are dressed by Janine Janet. Second Balenciaga perfume, 'La Fuite des heures'.

1950 Balenciaga shows collarless blouses, raincoats in Cracknyl by Bucol, and balloon dresses. Courrèges is taken on as a member of Salvador's atelier.

1951–52 For the first time, a more fluid line emerges, with suits and coats that skim the waist, smocks, camisoles – sometimes of lace – and embroidered evening gowns.

1953 Shorter basques on suits and stand-away collars. Dress waistlines drop to hip level; a more fluid line generally.
Tiny pillbox hats, in a collection praised by Carmel Snow as supremely tasteful.

1955 Balenciaga creates his first tunic, in linen for summer, in wool for winter and in lace for cocktail wear; the press adores it.
Balenciaga's third perfume, 'Quadrille'.

1956 Capes and sack dresses in tweed. Emmanuelle Kahn and Christiane Baily become models. The designer dresses Marie Daems for Marcel Carné's film *L'Air de Paris*, and Ingrid Bergman for *Anastasia*.
Balenciaga, soon to be followed by Hubert de Givenchy, shows his collections one month later than the other couturiers. The press are happy to make a special trip.

1957 Variation on the shift and the tunic, an even more simplified line that continues to revolutionize fashion.

1958 'Baby doll' dresses and so-called peacock-tailed dresses for evening. Abraham creates the fabric gazar, much used by Balenciaga. Balenciaga is awarded the Légion d'Honneur. Emanuel Ungaro becomes a member of Salvador's atelier.

1959 Suits with short boxy jackets. Higher waistlines.
Designs the dress worn by Madame Wessweller in Jean Cocteau's film *Le Testament d'Orphée*.

1960 His talent and technique are at their peak. Austerely simple designs in sumptuous materials.
Wedding of Queen Fabiola of Spain. Balenciaga goes to Madrid to make the bridal gown.

1961 Cleverly cut loose-fitting coats, evening gowns à la Zurbarán, duenna's dresses and magnificent negligées.
Courrèges leaves and opens up under his own name.

1962 Balenciaga launches a range of boots, executed by Mancini, which he teams with his sports outfits.

1963 A practical collection geared to modern life, with suits in Nattier tweeds inspired by hunting costumes. Rich and varied materials, with embroidered fabrics for evening. As a gift for his friend Jean Cocteau, he designs and makes the costume for Death in his play *Orphée*.

1964 Thick harlequin and patterned tights teamed with suits, ensembles in padded and *cloqué* fabrics. Emanuel Ungaro leaves Balenciaga.

1965 The year of saris in lamé materials for evening and of lacquered *cloqués* by Léonard. Praise in the press for a collection that yet again shows Balenciaga faithful to his vision, his own timeless and matchless style.

1966 Voluminous 'seven-eighths' coats of utter simplicity. Some longer versions with huge fur trims at the hem.

1967 Superb suits and cape and trouser ensembles. Increasingly pure and abstract forms.
The collection is praised for its mastery and originality.

1968 Brimming with colour and youth, likened in the press to a Rolls-Royce, this is Balenciaga's last collection. The emphasis is on shorter hemlines, and the *trompe-l'œil* effect achieved with tunics of a different length.
Design of the air hostess uniforms for Air France. Closure of the House of Balenciaga. Closure of the three Spanish-based businesses. Balenciaga retires to his house at Igueldo in Spain.

1972 Death of Cristobal Balenciaga at Javea in Spain, shortly after designing his last bridal gown for the Duquesa de Cádiz. He is buried at Guetaria in his native Basque country.

Balenciaga

Cover of the catalogue specially designed by Miró for the Balenciaga exhibition held in Madrid in 1974. © ADAGP, Paris 1997.
Black jet bolero embroidered by Lesage, shiny as a beetle's carapace, the effect softened by the satin dress worn by Maggy. Winter Collection 1961. Photo: Kublin. © Archives Balenciaga, Paris.

Frock coat in black silk brocade by Ducharne, worn here by Régine Debrise. Winter Collection 1950. Photo: Irving Penn, courtesy of *Vogue*. © 1950 (renewed 1978) Condé Nast Publications, Inc.
Portrait of Cristobal Balenciaga as a young designer in San Sebastián, in 1927. © Lipnitzki-Viollet.

The duenna and the Infanta on the balcony, the former in black satin with a pink bow in her hair, her companion in pink satin with a headdress of black ostrich feathers. Drawing by Bénito, published in *Vogue* in 1939. © All Rights Reserved.
Stage costume created for Alice Cocéa, in jet-embroidered black velvet by Ginisty, for her role in *Echec à Don Juan* at the Théâtre des Ambassadeurs in 1941. © Photo: David Seidner.

Mindful of their dignity, the duennas dress up for evening in gowns of marquisette, moiré and figured or lacquered satin. No. 113, Spring Collection 1962; nos. 53 and 24, Winter Collection 1961; no. 45, Winter Collection 1962; no. 130, Winter Collection 1964; no. 119, Winter Collection 1951.
Big hat of black grouse feathers, worn here by Dany, one of the top models at Balenciaga. Photo: Kublin 1961. © Archives Balenciaga, Paris.

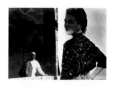

Balenciaga photographed by one of his closest friends walking in the cloisters at Fiteira in Spain, in the late 1960s. Photo: Raphaël Calparsoro.
Bolero embroidered with jet cabochons. Collection of 1940. Photo: André Durst. © All Rights Reserved.

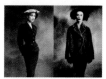

Suit in darkest grey wool ottoman worn with red velvet beret. Winter Collection 1950, from Salvador's atelier.
Barrel-line paletot in heavy duck-blue wool. Black ostrich feather hat reminiscent of the Infanta's headdress. Winter Collection 1950, from Henri's atelier. Photo: Irving Penn, courtesy of *Vogue*. © 1950 (renewed 1978) Condé Nast Publications, Inc.

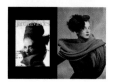

Black silk organdie hat partly veiling the face, worn here by Annick, one of the Balenciaga models. Winter Collection 1962. Cover of *Jardin des modes*, November 1962. Photo: Kublin. © Archives Balenciaga, Paris.
Suit in grey wool ottoman with green wool cloth stole and red velvet beret, worn by Régine Debrise. Winter Collection 1950, from Salvador's atelier. Photo: Irving Penn, courtesy of *Vogue*. © 1950 (renewed 1978) Condé Nast Publications, Inc.

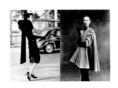

Tunic ensemble in black woollen cloth, with black fox fur collar and long hanging drape at the back, worn here by Ann Saint Mary for Henry Clarke. Winter Collection 1955. Photo: Henry Clarke. © ADAGP, Paris 1997. **Draped paletot**, open at the sides, in turtle-grey broadcloth: one of Balenciaga's most famous designs. Winter Collection 1950, from Lucia's atelier. Photo: Irving Penn, courtesy of *Vogue*. © 1950 (renewed 1978) Condé Nast Publications Inc.

Ensemble in figured satin by Raimon: short jacket with nipped-in waist with matching small draped shawl decorated with silk fringes. Winter 1950, from Claude's atelier. © Photo: David Seidner.
Pillbox in the style of a cap, spiked with twigs made of black varnished wood and jet beads. Spring Collection 1962. Two whole workshops at Balenciaga were devoted to making the hats for all the collections as well as for clients. © Photo: David Seidner.

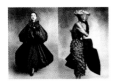

The balloon dress created by Balenciaga in 1950, of rustling black taffeta with small puffed cape to match.
Dress of feathers, of overlapping layers of pleated tobacco-coloured organza. Matching hat, contrasting with coat in embossed black taffeta: one of Balenciaga's favourite colour combinations. Winter Collection 1950, from Claude's and Denis's atelier. Photos: Irving Penn, courtesy of *Vogue*. © 1950 (renewed 1978) Condé Nast Publications, Inc.

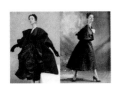

Coat in purple velvet by Ducharne, worn over a black taffeta dress . It is the clever circular cut which provides the exaggerated fullness and big collar. From Lucia's atelier, Winter Collection 1951. Photo: Henry Clarke. © ADAGP, 1997.
Cocktail coat in black faille, Winter Collection 1953. A big rose is set at the base of the neckline. The model is Suzy Parker. Winter Collection 1953, from Suzanne's atelier. Photo: Rawlings. © All Rights Reserved.

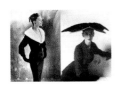

Suit in black satin with big shawl collar made of ermine, fastened with a black satin bow, and worn here by Suzy Parker. Winter Collection 1953, from Salvador's atelier. Photo: Rawlings, published in *Vogue*. © All Rights Reserved.
Big hat decorated with wings, a supremely stylish accessory worn with a suit displaying the longer basque that was the keynote look of the 1948 collection. Photo: Coffin. © Condé Nast Publications, Inc., British *Vogue*.

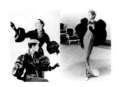

Voluminous sleeves: in black satin, shaped like Chinese lanterns, and in fine black padded fabric, echoing their respective jackets. Winter Collection 1951, from Denis's atelier. Photo published in *Plaisirs de France*. © All Rights Reserved.
Evening cape in black taffeta with flounces forming the sleeves, worn over a strapless sheath dress of pearl grey crepe. Spring Collection 1961, from Suzanne's atelier. Photo: Kublin. © Archives Balenciaga, Paris.

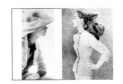

Profile view of white brocade suit with big hat in golden yellow organdie echoing the colour of the blouse. Jewellery of black jet beads in the shape of a heart. Summer Collection 1961. Photo: Kublin. © Archives Balenciaga, Paris.
Fitted suit in natural tussore silk by Hurel, set off by the voluminous swathes of taffeta forming the hat. Spring Collection 1951, from François's atelier. Photo: Harry Meerson. © All Rights Reserved.

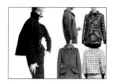

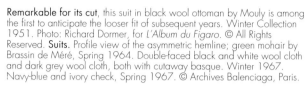

Remarkable for its cut, this suit in black wool ottoman by Mouly is among the first to anticipate the looser fit of subsequent years. Winter Collection 1951. Photo: Richard Dormer, for *L'Album du Figaro*. © All Rights Reserved. **Suits.** Profile view of the asymmetric hemline; green mohair by Brassin de Méré, Spring 1964. Double-faced black and white wool cloth and dark grey wool cloth, both with cutaway basque. Winter 1967. Navy-blue and ivory check, Spring 1967. © Archives Balenciaga, Paris.

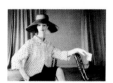

Paletot in white shantung with embroidered navy spots, worn by Maggy, the Australian model who was the favourite subject of Balenciaga's regular photographer, Kublin. Summer Collection 1960. Photo: Kublin. © Archives Balenciaga, Paris.

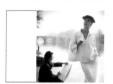

The sensationally successful smock 'La Marinière' in figured white piqué, modelled by Suzy Parker on the banks of the Seine. Summer Collection 1953. Courtesy of the Staley-Wise Gallery, New York. © Photo: Louise Dahl-Wolfe.

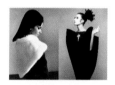

Black coat with white mink cape in the form of a small shawl, geometric helmet in black velvet, the point at the back echoing that of the cape. Winter Collection 1967. © Archives Balenciaga, Paris.
'Four-sided' cocktail dress in black gazar by Abraham. Cone-shaped, with the four corners at the top flaring outwards, paste straps. © Photo: Hiro.

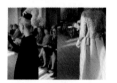

Tiny black velvet pillbox with pink ostrich feather, worn with a plain straight coat in black padded fabric by Mouly. Winter Collection 1962. Photo: Kublin. © Archives Balenciaga, Paris.
Evening ensemble in pink taffeta, jacket embroidered by Métral. Winter Collection 1962. Catwalk photo by Kublin. © Archives Balenciaga, Paris.

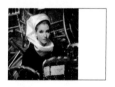

White satin coif framing the face. Collection 1965. Photo: Kublin. © Archives Balenciaga, Paris.

Evening gown 'Arum' in pink marquisette by Abraham, made in two petal-shaped sections. Winter Collection 1965, from Lucia's atelier. Photo: Kublin. © Archives Balenciaga, Paris.
Detail of a coat sleeve in heavy woollen fabric, known as the 'melon sleeve'. Winter Collection 1950. Photo: Irving Penn, courtesy of *Vogue*. © 1950 (renewed 1978) Condé Nast Publications, Inc.

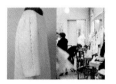

Detail of a collarless coat, loose-fitting, without fastenings or buttons, in heavy wool gabardine. Collection 1966, from Marcel's atelier. Photo: Claude Caroly for the BPI.
Balenciaga in his atelier conferring with his head seamstress, Madame Claude, before a fitting. Photo: Kublin, 1960. © Archives Balenciaga, Paris.

The fluid lines of a suit in a green and beige 'pebbly' tweed by Nattier, with cork buttons. Spring 1963, from Salvador's studio. Photo: Karen Radkaï for *Vogue*. © All Rights Reserved.
Classically cut black and white tweed coat lined in jersey. Winter Collection 1953, from Denis's atelier. Photo: Rawlings. © All Rights Reserved.

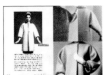

The disciplined genius of this coat marks Balenciaga's decisive move towards formal austerity. Spring 1967. Photo: Georges Saad, published in *L'Art et la mode*. © All Rights Reserved. Detail of the cut of a 'voluminous' coat in double-sided wool fabric; Winter 1959. Coat with integral sleeves, in almond green duveteen by Nattier; Spring 1964, from Emanuel Ungaro's atelier. Coat in red wool cloth by Nattier; Winter 1964, from Félissa's atelier. © Archives Balenciaga, 1954.

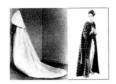

Trapeze-line wedding gown of stunning formal simplicity, in zagar by Abraham, with matching headdress. Spring Collection 1967, from Suzanne's atelier, Photo: Kublin. © Archives Balenciaga, Paris.
Long mink coat over white satin pyjamas, worn by Maggy. Winter Collection 1951. Photo: Kublin. © Archives Balenciaga, Paris.

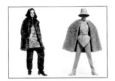

Luxury combines with comfort in this sable fur ensemble over a loose top of striped lamé, with headwear and boots in maroon velvet. Winter Collection, 1967, from Félissa's atelier. Photo: Kublin. © Archives Balenciaga, Paris. Sporty ensemble of cape in bright green wool by Garigue and stretch fabric ski pants; a number of models were made of this easy-to-wear material. Winter Collection 1967. Photo: Kublin. © Archives Balenciaga, Paris.

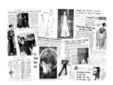

Press cuttings that reflect Cristobal Balenciaga's pre-eminence in the world of fashion, with pictures of some of his most famous creations, including the long coat of leopard fur, the trapeze-line dress of the later years, and the scoop neckline and patterned tights of the early 1960s. Also shown is one of the famous studded sculptures by Janine Janet, made especially for Balenciaga's shop windows. Presse des Archives Balenciaga, Paris.

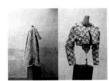

Negligée of bright pink satin shantung with embroidery of coloured flowers, by Abraham, owned by Madame Bedaux, one of the designer's major clients. Collection Archives Balenciaga, 1960.
Bolero embroidered with mother-of-pearl flowers on gold net, by Lizbeth, designed to be worn over a long dress of ivory satin. From Lucia's atelier, Winter Collection 1966. © Photos: David Seidner.

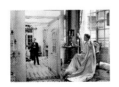

Portrait of Balenciaga in his boutique at Avenue George V. Seen on the right is the door to the lift, inspired by a sedan-chair and faced in cordovan leather – who knows how many distinguished clients used it over the years? © Photo: Gyennes, Madrid.
Negligée in pale blue satin by Abraham, worn by the Countess Bismarck, photographed by Cecil Beaton in her home at the Hôtel Lambert. Winter Collection 1955, from Denis's atelier. © Sotheby's, London.

Evening gown with the so-called peacock-tail train. Embroidered by Lesage with silk flowers and multicoloured precious stones on tulle. This dress is on display at the Museum of Costume in Barcelona. Collection 1958. Photo: Kublin. © Archives Balenciaga, Paris.

The author and publishers would like to thank the Maison Balenciaga, and in particular Jacques Konckier and Monsieur Balenciaga's former colleagues.

Our thanks are due to Monsieur Balenciaga's family, to Hubert de Givenchy, Raphaël Calparsoro and Séverine Jouve.

Also to Irving Penn, Jean Kublin, David Seidner, Hiro, Gyennes, Richard Dormer, Jacques Verroust, Geneviève Gambini.

Finally, this book would have been impossible without the help and efficiency of Lorraine Mead (Condé Nast Publications, Inc.), Shelley Dowell (Studio Hiro), Alice Morgaine (*Jardin des modes*), Nicole Chamson (ADAGP), Liz Stasney (*Harper's Bazaar*), Françoise Giroud (Bibliothèque Publique d'Information), Michèle Zaquin (*Vogue*), Tiggy Maconochie (Hamilton Photographers), Lydia Cresswell-Jones (Sotheby's, London), Irenka Gyennes (Studio Gyennes), John (Camera Obscura), Michèle Lajournade (Roger-Viollet), Etheleene Staley (Staley and Wise Gallery), the Bismarck Foundation and Les Éditions du Regard.

Our thanks to them all.